WEDDING PHOTOGRAPHY

CREATIVE TECHNIQUES FOR LIGHTING, POSING, AND MARKETING

FOR DIGITAL AND FILM PHOTOGRAPHERS

Rick Ferro

AMHERST MEDIA, INC. ■ BUFFALO, NY

To Deborah,
Thank you for always being there for me. Thanks for all of your support and love.
Your husband, Rick

Copyright © 2005 by Rick Ferro
All rights reserved.
Photographs on pages 7, 70, 77 (top right), 96, and 100 by Deborah Lynn Ferro.
Photographs on pages 59 (bottom center), 77 (bottom left), 89 (top), and 91 by Kyle Scott.
All other images by Rick Ferro.

Published by:
Amherst Media, Inc., P.O. Box 586, Buffalo, N.Y. 14226, Fax: 716-874-4508
www.AmherstMedia.com

Publisher: Craig Alesse
Senior Editor/Production Manager: Michelle Perkins
Assistant Editor: Barbara A. Lynch-Johnt

ISBN-13: 978-1-58428-142-9
Library of Congress Control Number: 2004101344

Printed in Korea.
10 9 8 7 6 5 4 3 2 1

ABOUT THE COVER SHOT

The image on the front cover was taken during a class I conducted. When I set up the shot at high noon, I'm sure my students were thinking, "What about lens flare? What about glare?" Despite the fact that the sun was directly overhead, I knew that positioning the reflector just right would produce beautiful light. I showed one of my students where to hold the reflector, then got the bride in position and went to the camera. The funny thing is, this was the only image I shot—I stepped out of the way and let the class have fun. Little did I know it would end up as a book cover!

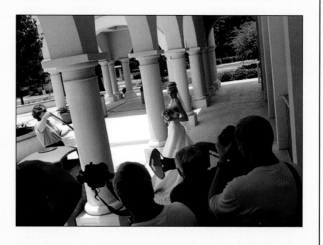

TABLE OF CONTENTS

FOREWORD

The first time I saw Rick Ferro, I was walking with my wife and her girlfriend at the WPPI convention and trade show in Las Vegas. My wife's friend, seeing Rick walk by looking dashing in a black suit, white shirt and silver tie inquired, "Who is that? He looks like a movie star!" I didn't know Rick at the time, but I had been hearing a lot of great things about him. I heard him speak to a group of about five hundred at that convention and liked him right away.

Rick Ferro is one of the finest wedding photographers in America, and he is a first-rate teacher, as well. But you'd never know these things by talking with him. His self-effacing style and good-natured humility are what strike you as his most notable attributes.

But be assured he is a giant in the wedding photography business. He has photographed many thousands of weddings and his craft is second nature to him. The depth of his skills goes far beyond his complete mastery of lighting, posing, and the technical aspects of good wedding photography. His true gift is the unique ability to make all of his brides look beautiful. Average-looking brides, big brides, little brides—it doesn't matter. They all become Rick Ferro brides.

Rick has a spirit of generosity that is second to none. When I first began writing books for Amherst Media, I called on Rick to help me out with some of his award-winning images. He not only readily complied, but also was willing to explain why a certain shot was great and what went into the making of each of his images.

I have heard Rick lecture to photographers many times now and I am always amazed at how he inspires people. He treats his students much like he probably treats his brides—making them feel special and unique. His students come away with a new vision of the possibilities they can achieve artistically. Rick is a giving person, and he doesn't hold back with people. He will explain to you in great detail how he made a certain shot or how you could make a similar shot. But he doesn't inspire people to copy other photographers. Instead, he inspires other photographers to forge new creative ground of their own—to take a step up to the next level technically and artistically.

Rick Ferro's skills as a teacher and communicator also make him a fine writer and also explains why his wedding books for Amherst Media have become so successful. It is rare that a photographer can fill a book with his own work and not have it look monotonous. Rick is the notable exception. His work is fresh and innovative and his texts are clear and insightful.

As a photographer, Rick is a student of the formal side of wedding photography. He is perhaps the best practitioner in the country of the formal bridal portrait. These formals have given Rick great notoriety among the professional photographic organizations like PPA and WPPI (with which I am associated). Many of his bridal formals have gone on to win

Grand Awards in print competition and are still used as examples of the best of the best of formal wedding photography. In terms of his style, Rick actually manages to do the impossible: he combines the elegant posing traditions of the past with elegant contemporary lighting techniques. The result is images that are simply timeless.

Perhaps the greatest form of flattery is imitation. At WPPI's annual print competition, when referring to a bridal portrait, it is not uncommon to hear someone say, "It looks like a Rick Ferro print."

—Bill Hurter, Editor
Rangefinder magazine

ACKNOWLEDGMENTS

Thank you to: Fujifilm, Inc.; Buckeye Color Lab; Collages.net; Albums, Inc.; Bosh Lighting/Albums, Inc.; Equipment Department; Amherst Media; Desktop Darkroom; Photo Barn; Denny's Manufacturer; Quantum Instruments; and Sky High Backgrounds.

A special thanks for their contributions to: Jackie Barrickman, Clay Blackmoore, Kevin Casey, Will Crockett, Tom Curley, Sherri Ebert, Lori Gragg, Bill Hurter and *Rangefinder* magazine, Tim Kelly, Tomas Munoz, Michelle Perkins, Troy Reichenbach, Mr. Rosen, Martin Schembri, Kyle Scott, Gregg Sessions, Wanda Tankersley, and Bruce Wilson.

INTRODUCTION

Before I started writing this book, I picked up a few wedding photography books. Some were interesting, but many started by asking you to read chapters like "What is a Wedding?" or "What Equipment You Should Use," or even titles to the effect of "Check out Our Great Photos of the First Dance at the Reception." This book is not like those. Instead, I wanted to reach out to the photographers who plan ahead and work hard to deliver the wedding album of their clients' dreams.

Beginning with pre-wedding planning, you'll learn how to guide your clients through all the steps of photographing their wedding. Next, you'll see how to create portraits of the bride. We'll continue on to look at portraiture of the bride and groom, covering shots of the ceremony, posed images in the church, and environmentals. Chapter 3 expands to cover techniques for photographing the couple with their attendants and family. Chapter 4 explores lighting and posing groups. Chapter 5 covers the subject of marketing—since one of the goals of wedding photography is to actually make a living!

Wedding photography is a challenging field that demands creativity and style. This book will help you gain the knowledge and flexibility you need to achieve images that will make you proud and set you apart from the crowd.

● *About the Author*

Rick Ferro is one of the nation's leading wedding photographers. He holds a Master of Photography degree from PPA (Professional Photographers of America) as well as the title of PPA Photographic Craftsman and a Masters degree from WPPI (Wedding and Portrait Photographers International). In 1993, Walt Disney World approached Rick to create a wedding photography department. He became Senior Wedding Photographer for Disney—and Disney became the world's most sought-after wedding destination! As the department grew, it became an avenue for television weddings, and Rick served as a photographer for ABC's *Weddings of a Lifetime* and for weddings on *Live! with Regis & Kathy Lee*. Rick is widely regarded as one of the nation's leading wedding photography instructors and speaks regularly to standing-room-only crowds at national photography conventions. For more on Rick, visit him online at either of his websites: www.rickferro.com or www.ferrophotographyschool.com.

1.

BEFORE THE WEDDING

BRIDAL PORTRAITS, ENGAGEMENT PORTRAITS, AND

PLANNING THE WEDDING-DAY PHOTOGRAPHY

PRE-PLANNING

A very important factor in successful wedding photography is how well you and your clients plan for the shoot. A very coordinated and guided approach will ensure that the couple's wedding album is exactly what they wanted and will help guarantee that the shoot runs smoothly and is fun for your clients.

A meeting with the client to discuss planning before the wedding is essential. We invite our clients to the studio and work with them to lay out plans for the day. Although we have specific needs (in terms of time, etc.), we make sure not to make the clients think that they will have to do it our way. Rather, we make it clear that this is their special event. We want to work with them to make sure not only that the day is wonderful, but also that they have the images they want to remind them of it.

Pre-wedding consultation with your client will naturally include planning and scheduling for the wedding day. Images in the church and of the ceremony are extremely important and should be covered in detail to ensure that you don't miss an image the couple wanted. You'll also want to discuss locations other than the church at which the couple would like to shoot. These environmental portraits offer you a unique opportunity to capture the style and romance of the happy couple. Having a few favorite locations to recommend to clients can be very helpful.

PRE-WEDDING CONSULTATION CHECKLIST

A pre-wedding consultation with the couple is crucial to a smooth and successful shoot—as well as for pre-wedding studio portraits. Below is a checklist you may wish to use to ensure you cover all the necessary topics at every consultation.

1. Create a comfortable, friendly, and professional atmosphere. Serve refreshments. Clients will be spending a lot of money on your services; make them feel appreciated.
2. Confirm dates, times, locations, and schedule for the wedding day.
3. Record the phone numbers and addresses of the bride, groom, and parents.
4. Discuss pre-wedding studio portraiture (including engagement portraits) and invite the bride to come to the studio three weeks before the wedding for a photo session.
5. Create a signature set of "special shots" to add to the ones you normally take. This could include special family members, friends, etc.
6. Discuss environmental photos to be taken on the wedding day.
7. Discuss the photographs, poses, and groupings included on page 116–18.

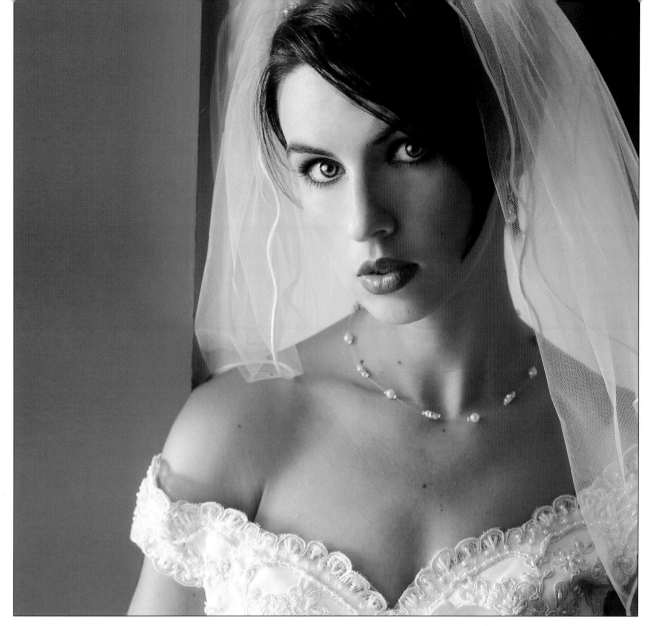

When you sit down with your clients, you'll also want to be sure to discuss pre-wedding images in the studio. We stress the importance of a formal bridal portrait. It's a great dress rehearsal for the wedding and gives the bride a chance to test out her hair and makeup before the big day (when there's enough time to make any needed changes). We suggest that she have her bouquet made up for the bridal portrait so it can be included in the pictures. It can then be preserved to serve as her toss bouquet on the wedding day. We suggest doing your bridal portraits at least five weeks in advance of the wedding so there's time to sell the couple a large framed canvas to display at the wedding.

At our bridal portrait sessions, we try to create twelve images (including full lengths, high key portraits, head and shoulder shots, and low key images). These should be elegant and display the bride's natural beauty. Capturing the look of the bride is an important part of the wedding photographer's job, since these images are important to the success of the album. The rest of this chapter covers the techniques needed to create dramatic studio wedding portraits.

Pre-ceremony group images on the wedding day should also be discussed. Turn to page 92 for more information on this important topic. On the facing page is a list of topics to cover in your pre-wedding consultations with clients.

THE MAGIC OF MAKEUP

Makeup artist and hairstylist Kari Larsen suggests these guidelines on makeup for bridal photography: When doing photographic makeup you must know what look the photographer and client are going for—natural, semi-natural, dramatic, or very dramatic. As noted below, you must also keep in mind that makeup application differs for black & white and color imaging.

● *Color Images*

For color, you'll want the end results to look perfectly blended and flawless. Select colors to naturally enhance the beauty and shape of the bride's eyes, lips, and bone structure. In photographs, the colors will appear more muted to the human eye, so makeup should be enhanced to one or two shades deeper than for daytime wear.

For eyes, avoid too much color. I always choose neutral tones, which enhance without being too visible. I start with an overall color (like cream) then use darker colors for shading. Blend the colors well and carefully. Remember, we want to see the subject, not the makeup.

For lips, select a color to complement the subject's eyes and hair. Either a glossy or matte finish can be appropriate, depending on the look you want. Glossy lips are great for dramatic images; matte lips look more natural. For cheeks, I tend to use very little color—just enough to enhance the bone structure. After applying a little color, I blend it in with a sponge to soften it. To finish the look, I go over the

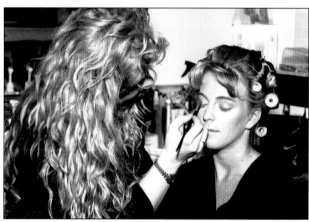

entire face with my sponge, then use a translucent face powder to eliminate all shine.

● *Black & White Images*

Makeup looks much more muted in black & white than in color. What would look very dramatic in color will look merely natural in black & white; what would look natural in color, will look washed out in black & white. Therefore, you need to apply the

bride's makeup much more heavily for black & white than for color. Reassure the subject that, although her makeup may feel caked on, it will look great in the photos.

Application should proceed the same way as for color images, but remember that color will not show up, so you need only worry about the shading and highlighting.

● *Both in One Sitting*

It's easier to add makeup than to remove it, so going from a natural look in color to a natural look in black & white is usually easier than the reverse. The key is good communication with the photographer, and making sure you both know what the outcome is going to be.

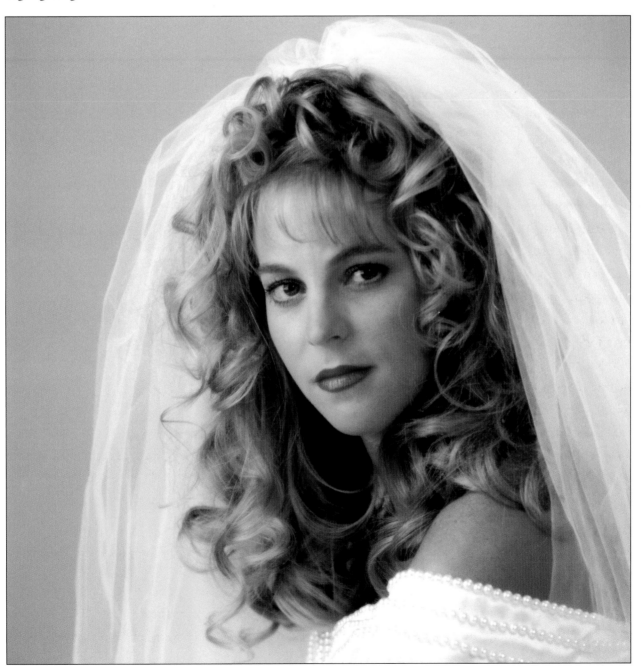

ELEGANT HAND POSING

● *Veil as Backdrop*

A beautifully simple backdrop for a bridal portrait is the bride's own veil. We use this technique in the studio and also on location—usually on the staircase of the church.

To get the shot, my assistant and someone from the bridal party simply hold the train up high to create a backdrop.

It's an easy method that works—and one I urge you to try for yourself.

● *Hand Posing*

When photographing a bride, what do you do with her hand posing to create a more dramatic look? The photos included below and on pages 16–17 show some simple, yet elegant answers to that very important question.

As you can see in this series of images, even without changing the lights, camera position, or background, you can create a number of very unique bridal portraits simply by moving the subject's hands

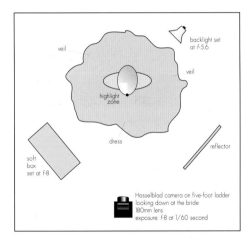

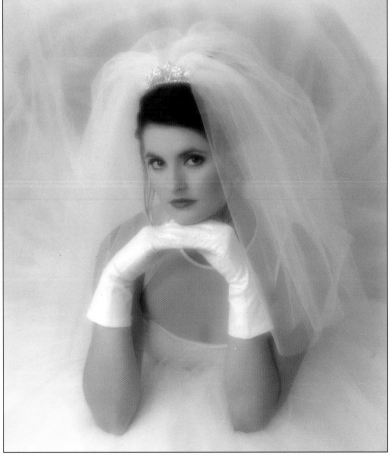

MORE ON THE PRE-WEDDING CONSULTATION

When you have prospective clients in for a consultation, you should create an atmosphere that is comfortable and professional. Make sure you are well groomed and dressed neatly. Be well prepared for every meeting. You need to be sure of your prices and prepared to talk about things that your clients won't even have thought about, like the benefits of no-flash photography during the ceremony.

When our guests arrive, the last place we take them is the consultation room. Why? We don't want to get into the expenses just yet. Instead, we take them on a tour. First, we show them the studio. This lets them know that we are experienced professionals in all aspects of the field. Next, we walk them down our "Hall of Fame" where we display some of our best work. Don't be afraid to flaunt your accomplishments and show clients the kind of work they can expect from you. If you've shot at their church or wedding site before, be sure to point out those images.

Next, we move on to the consultation room and discuss what kind of photographer the client is looking for. We then explain our style of photography. We produce a love story, starting with an engagement photo, then an elaborate bridal photo session with hair and makeup, then photography at the wedding. We like our albums to contain not only traditional photos, but some panoramic pages, some black & white photos, and some handcolored images.

Still, we do not discuss prices. Instead, we sit with the clients and go through sample albums, folios, and gifts items. We control the sample al-

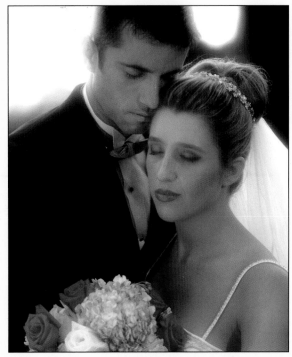

bum, turning the pages and explaining the images. Get involved and be enthusiastic. Most of all, don't be in a hurry. We sometimes spend as much as one to two hours discussing the wedding day with our clients. When you are done looking at the albums, it's finally time to discuss your prices and packages.

I don't go into much more detail at this point because I want to give the clients some time to review what we have already discussed. By the time we've finished our conversation, clients know that we are not just an average studio, but a studio that wants them to be educated consumers.

Within a week after our consultation, we send the clients a gift box of wallet-sized images from some of our special weddings and a congratulations card. We then follow up with them by phone in about two weeks.

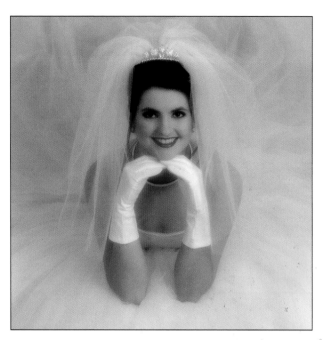

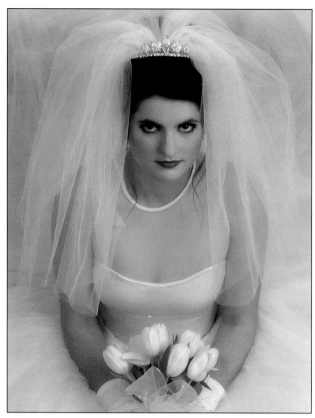

(or adding the bouquet, as was done for the image to the right).

● *Camera Position*

Another important element that helps give this series of portraits their unique flavor is the fact that I shot them all from a ladder. Buying yourself a small stepladder is a good investment that will allow you a simple way to get a new angle on your portraiture.

● *Composition*

You'll notice that I rarely place the subject in the center of my portraits. It could be tempting to do this, especially since the subject is the whole reason for taking the portrait in the first place. Still, compositions that encourage the viewer's eye to move across the image (rather than letting it freeze dead center) are ultimately more compelling and more interesting to look at.

● *Awards*

The photo on the opposite page is called *Solitude* and has won many awards, including a merit at a national convention of Professional Photographers of America. It has also appeared on the cover of *Rangefinder* magazine.

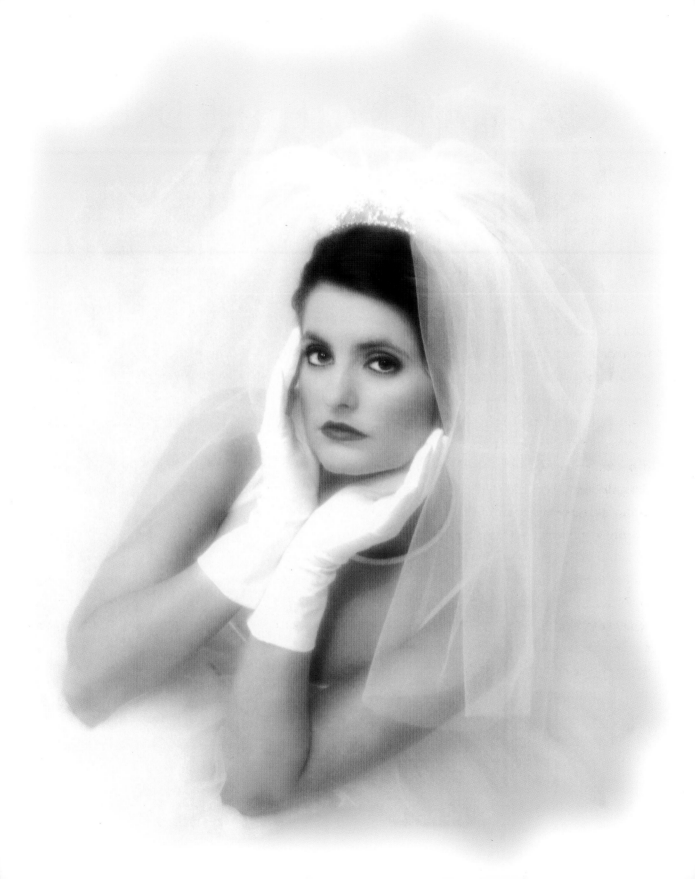

GLAMOUR WITH THE DRESS

In the previous section (pages 14–17), we saw examples of using the bridal veil to create a glamorous background. Here, the gown was used in a similar way in an outdoor setting. You'll need two assistants for this shot—and a bridal gown with a full skirt.

When creating this type of image, the first thing to consider is the natural lighting. Place your subject with her back to the sun. Then, generalize the pose and get the bride situated.

With the bride in place, place one assistant on either side of the bride and have them lift the top layer of the back of the dress (bridal gowns usually have numerous layers of fabric in the skirt to give them their volume, so the bride need not worry about modesty!). The assistants should lift the fabric high enough to fill the area behind the bride's head as you look through the lens. Have them carefully stretch the fabric horizontally to eliminate any wrinkles or ripples in the material.

The final step is to add fill light to the setup, opening up the shadows and adding nice catchlights in the bride's eyes. This can be done using a reflector or a bare-bulb flash unit (see page 68). For the portraits shown here, I used a bare bulb set to one stop less than the exposure reading for the shadow side of the bride's face.

Once you've created this setup, try several different angles for more dramatic results. Shooting from a short stepladder will remove any hint of a double chin (if there is one). Keep the flowers to a minimum to make the most of the creative backdrop.

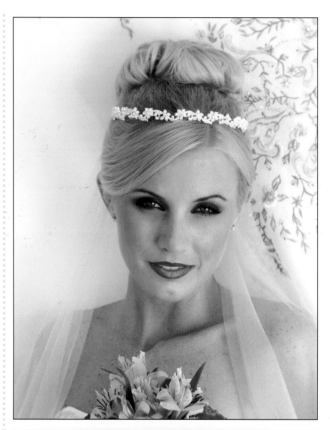

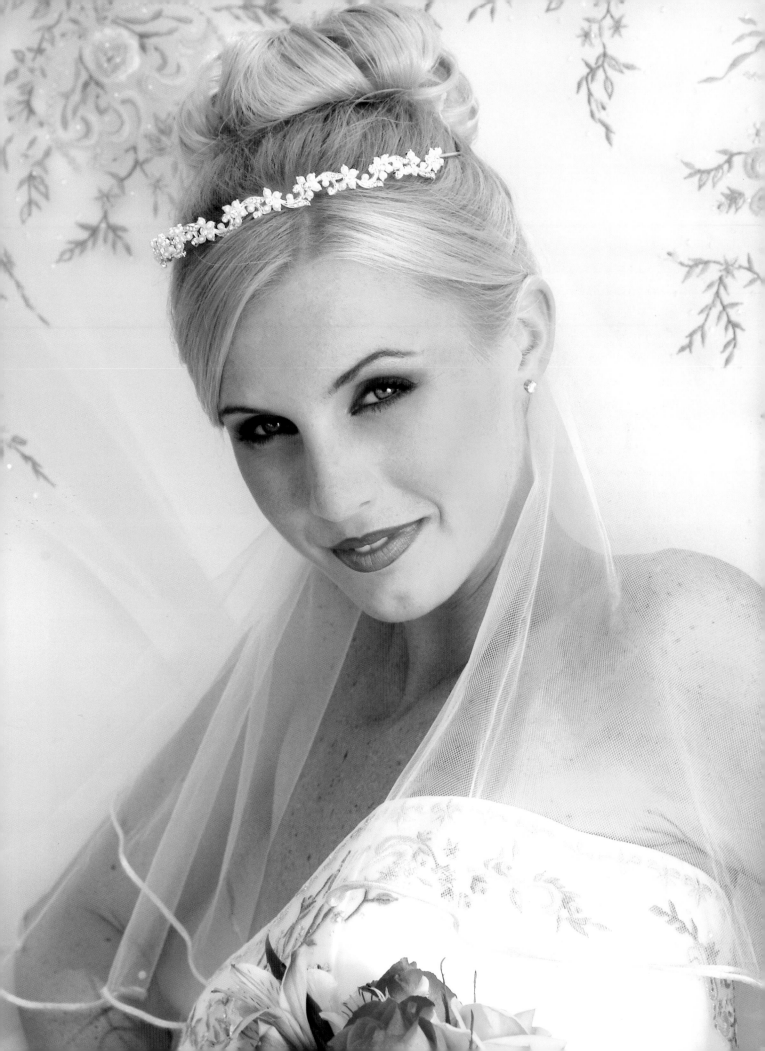

BRIDAL PORTRAITS

● *Lighting*

A low key image like this is a nice addition to a bridal album, so I make sure to shoot some during every bridal portrait session. I like to keep the lighting as simple as possible and make an exposure at about f-8 or f-11. Metering for this image was done close to the face to ensure that it would be properly exposed and that the background would go totally black. The main light was placed to the left side to create shadow detail. An umbrella was used over the camera, and a hair light was added above the subject to highlight her hair.

● *Posing*

After the bride's hair and makeup had been expertly styled (bottom right), we shot a series of poses including a profile (top right) and a three-quarter pose (facing page).

When positioning the subject's face to create a three-quarter view, turn it just until his or her far ear disappears. Then, make sure to leave a bit of the face showing beyond the far eye.

In the profile, notice how the subtle edge lighting helps to separate the subject from the background. Be sure to pose the subject for a complete profile. Anything else will not create the proper lighting pattern. The light must come in at a 45-degree angle and quite high. Here, the main light source was a soft box placed to the left of the subject and back to create the triangle of shadow on her face. This is called a Rembrandt lighting pattern.

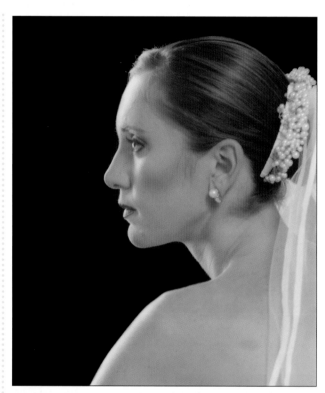

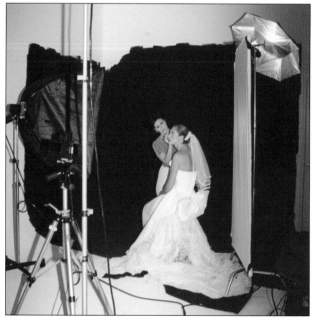

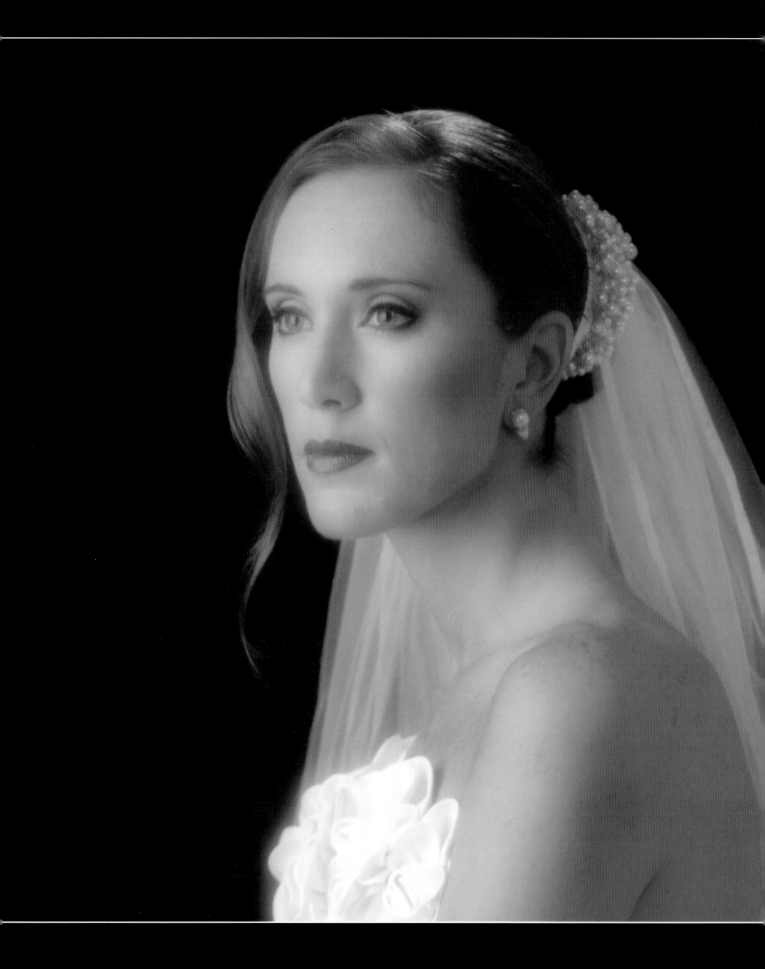

PICK A KEY

● *High Key Images*

The importance of the white bridal gown in the wedding tradition is reason enough to consider doing some high key portraiture. But high key images are also a big seller—canvas, 20 x 24-inch prints, you name it, they want it. Clients call it white on white, but no matter what you call it, it sells.

I lowered the camera angle and shot mid-range for the image shown below. The lower camera angle makes the bride seem taller.

The diagram below will help you set up the lighting for this beautiful, full-length shot of the bride and bouquet. Our studio is quite large, so this lighting setup was appropriate. It is certainly possible, however, to create a beautiful high key portrait with other combinations of lights. For our setup, the two back lights were set at f-16. Barndoors were used to prevent spill on the subject. The main light was set to a half stop less (f-11½), allowing the backlights to create a totally white background. The fill light was set at f-8½.

If your image isn't quite perfectly white (especially at the top or bottom where shadows could occur), you can ask your local lab to dodge these areas or you can dodge them yourself using Adobe Photoshop.

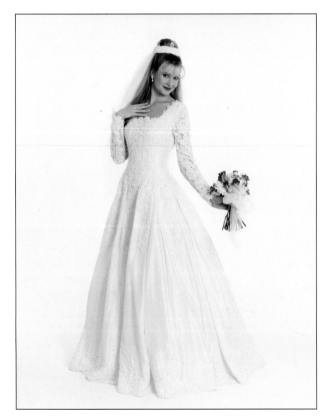

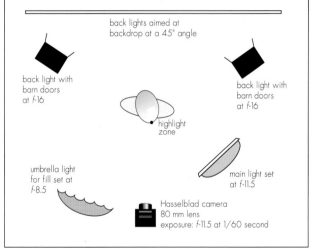

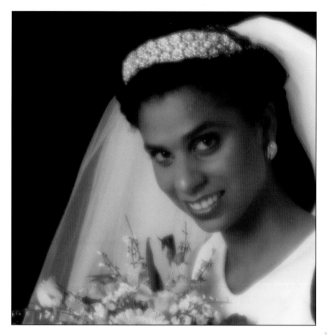

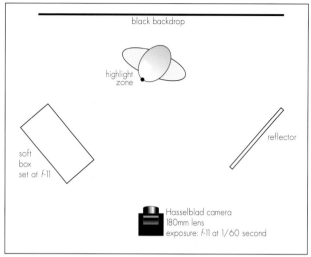

● *Low Key Images*

Low key images are also a popular style for bridal portraits. You can see two more examples of low key bridal portraiture on pages 20–21.

For our purposes in bridal portraiture, "low key" means nothing more than switching to a dark background. As you can see, the contrast between this dark background and the white bridal dress and veil creates a very striking and appealing image. It is a sophisticated look that appeals to many clients.

I like to keep the lighting as simple as possible for low key images. For the image above, the bride was placed in front of the black background. The main light was positioned at about a 45-degree angle to the right of the bride. A reflector was used to the left of the bride to add a little light to the shadow areas of her face. By all means, light up the veil as well, using a light source set for the same exposure as the fill light. Finally, remember to adequately use light to separate the subject from the backdrop.

Low key lighting can be a bit trickier than middle or high key; the secret is to provide enough light for a good exposure (I like to shoot between f-8 and f-11), but not so much that you start to lose detail. To meter properly, point your meter toward the main light source.

Don't forget to look for places to create low key images on location. As seen below, window light can be very beautiful for this type of portrait.

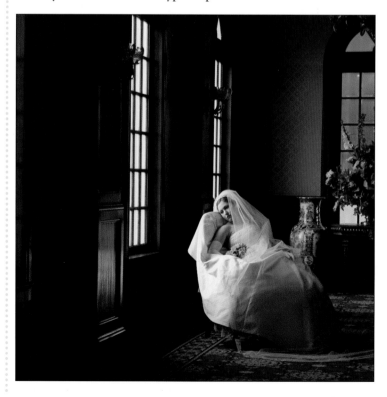

ENGAGEMENT PORTRAITS

● *The Benefits*

The engagement portrait session is usually the first time you will be working with your new clients. It's the time to build a good rapport with your clients and to make them feel good about themselves. In addition to preparing them for what to expect during the photography on their wedding day, you can also instruct them in the basics of posing for photographs. This will make things go more quickly during the wedding-day photography—meaning that the couple can get back to their guests more quickly and you can work more efficiently.

● *Preparing for the Session*

Unlike on the wedding day, when the bride and groom's clothes are pretty much predetermined, for the engagement portrait, the couple will need to select their own outfits. Advise them as you would portrait clients—and remember that coordinating outfits will make the two really look like they belong together. Discuss whether the couple prefers a studio or location portrait and a formal or casual look. Ask them where they want to display their portrait and think about ways to design an image that will perfectly suit that use.

GETTING STARTED

● *Training*

To get started in wedding photography, you should prepare for a substantial investment in equipment, energy, and time.

There are many ways to learn the needed skills and further develop those you already have. Even if you graduate with a photography degree, your training in the real world continues every day. Join your local photography organizations. They always have something going on—whether a meeting or a seminar. They can be a great help as you get your career under way. Some groups also have monthly publications loaded with helpful ideas and information. There are also many books and videos available that can help you achieve the results you want. Classes are an especially great way to learn photography, and I would advise you to take advantage of as many of these as you can afford. Another great way to start is by donating your time as a weekend assistant to an established wedding photographer. Better yet, try to assist several photographers, so you'll benefit from the variety of their skills and experiences. This will also give you training with a variety of equipment.

Photography is an art you never stop learning, and the effort you put into acquiring the professional techniques of the craft will pay off exponentially.

● *Portfolio*

To sell your skills, you'll need a portfolio of wedding images. If you assist another photographer, he or she may allow you to shoot a few candids at a wedding.

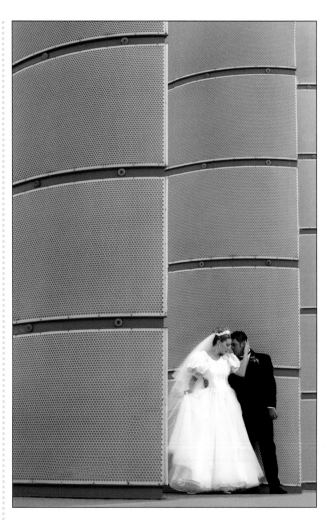

Also, consider introducing yourself to a local bridal shop and asking to borrow some of their gowns to do some samples for them.

If they consent, find a model and take her out into the field with this book. Don't try to learn everything, but rather focus on one pose at a time and learn it well. (You may also be able to secure permission to shoot in a church during the week to add a little variety to your sample images.)

Then, return to the bridal shop with a few great prints as trade and leave them your card. This is a great way to get started.

As you increase your skill and business, you may wish to compile several portfolios to match the varying budgets of your clientele. If you decide to open your own studio, you should also plan to invest in professional framing and a few canvas prints. This will tell your clients that you are a professional and that they will be happy with your work.

● *Pricing*

You must think through and establish a game plan so you won't need to hesitate when clients ask for a price. For a new photographer, the most important thing to keep in mind is your cost. Make sure to include your processing, batteries, assistants, albums, enlargements, insurance, square footage space you own or rent, travel expenses, and your basic wage (plan on six to eight hours for a wedding).

● *Packaging*

Determine what kinds of packages will work for you. There are infinite variations. It's important to remember that, whatever packages you offer, clients are ultimately paying for the *quality* not the *quantity* of your work. You need a lot of great images to fill an album, but not at the cost of quality.

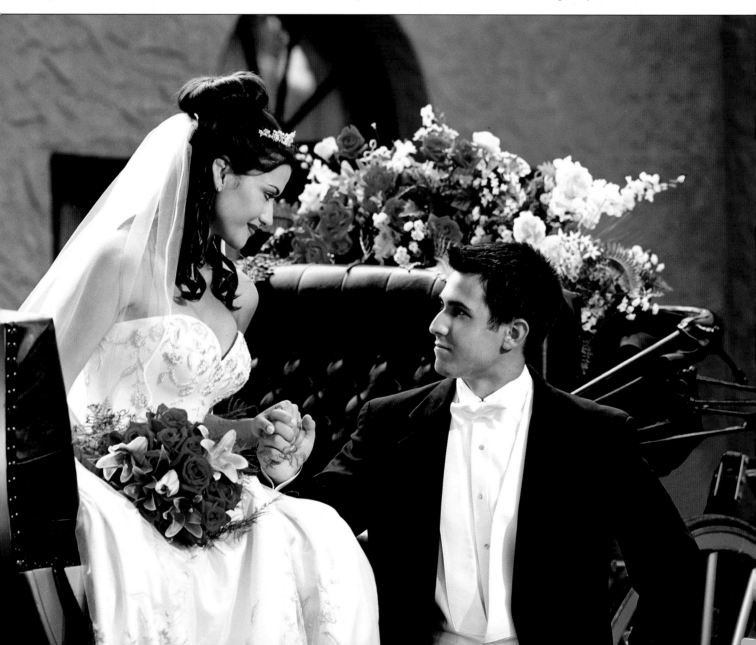

CREATING TOP-QUALITY FILES

When shooting digitally, exposure is critical. Although you can correct poor exposures in Photoshop, they will never have the quality as images that were properly exposed. Where exposure is concerned, photographing digitally is basically the same as using slide film; there is only ³⁄₁₀ stop latitude on the highlight side, and ⁵⁄₁₀ stop latitude on the shadow side. Therefore, exposure has to be almost exact.

Most photographers use the histogram on their camera to check exposures. However, this histogram accounts for all the light that is coming through the lens for the *entire image*, so it won't help you ensure that your subjects are correctly exposed. The best way to test this is using a technique called the "face mask histogram," taught to us by Will Crockett.

When working in a controlled lighting situation, open a test image in Photoshop. Using the Elliptical Marquee tool, select the subject's face as seen in the top image (right). You want to make sure that you get a portion of the subject's hair, under the chin, and excluding any of the background. Next, go to Image>Adjustments>Levels to bring up a histogram. The histogram shown here is what a properly exposed histogram for a portrait should look like.

Obviously, you cannot do a face mask histogram at a wedding. Using the proper white balance setting, however, will dramatically reduce the amount of time you spend color balancing your images and make your files easier for the lab to print. Combined with proper metering techniques, you'll be assured of more consistent exposures.

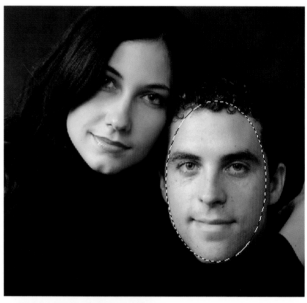

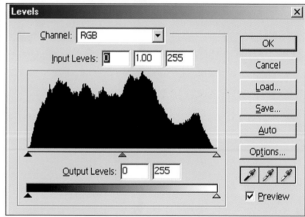

Another concern when creating top-quality files is color space. 35mm-type digital cameras capture images in the sRGB color space, and professional labs print in the same color space. If you change it to anything other than sRGB, the lab will have to change the color space back to sRGB in order to print, and this will negatively effecting your printed image. This does not apply to large-format digital

cameras (i.e. digital backs, etc.) or to when you print using your own inkjet printers (for which you may be using the Adobe 1998 color space and ICC profiles specific to your printer).

In this discussion, we cannot forget about proper monitor profiling. Most photographers would rather spend their money on new toys like cameras and lenses rather than invest in a monitor profiling kit, but a calibrated monitor is an essential part of getting great results from digital files. We use the Fuji Colourkit Profiler for our LaCie monitors. Your monitor should be calibrated every two to four weeks to keep it consistent.

All of this can make your head swim, so Fujifilm has given us some great advice that has helped us tremendously:

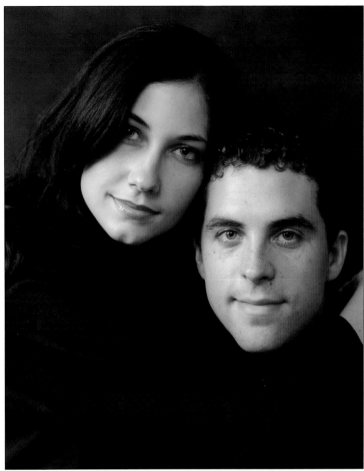

1. Exposure values can be easily and accurately contained by proper use of an exposure meter as outlined by the meter's manufacturer.
2. Stay inside the sRGB color space by capturing and working in the sRGB color space. If your camera allows the tagging of ICC profiles other than sRGB, select the sRGB option. The native color space of many professional digital cameras is sRGB, and Fujifilm recommends the sRGB option as the working space for file manipulation when using Adobe Photoshop. Photographers who alter the color space of the original file by using a space other than sRGB, without being fully ICC aware, are actually damaging the files they submit to their labs.
3. Custom white balance is the most accurate method of setting image capture neutrality.

Follow the procedure as outlined in your camera manufacturer's user guide.
4. Creating a custom monitor profile is vital to analyzing file color and exposure values. Use a monitor profiling system, such as Colourkit Profiler to neutralize your monitor's display.

If you practice these four principles, you will be able to achieve excellent file quality. Lab costs may begin to rise because of the improper files many photographers have been sending them, so you can do yourself a favor by getting this right. Remember, lower lab costs mean higher profits!

For additional information on this absolutely critical topic, please visit www.shootsmarter.com or www.ferrophotographyschool.com.

2.

THE
CEREMONY

AND POST-CEREMONY PORTRAITS AT THE ALTAR

PREPARING

● *Meet the Minister*

The first thing I do when I arrive at the church is introduce myself to the minister. This is especially important if you have never worked at the church before. Regardless of the denomination, most churches will not allow you to use flash during the ceremony (remember, this is an important religious ceremony, not just a social event). I let the minister know I will not be using flash, and that, in fact, he will probably not even see me during the ceremony.

Then I explain that I will need to do a few posed shots at the altar after the ceremony. These include a shot of the couple with the minister, a re-creation of the ring exchanges between the bride and groom, and a re-creation of the couple's first kiss as husband and wife.

● *Flash Photography*

I do not like to take flash photos during the ceremony, as I think it takes away from the mood of the

CEREMONY PHOTO IDEAS

The list below gives you some examples of the shots you can try to get as they are happening during the ceremony.

1. Parents coming down the aisle
2. Parents lighting candles
3. Each bridesmaid (separately)
4. Flower girl
5. Ring bearer
6. Bride and Dad before they walk down the aisle
7. Bride coming down the aisle
8. Bride kissing dad on altar
9. For Jewish weddings, Mom and Dad kissing bride before giving her away

This list suggests some wonderful additional shots you should definitely try to get once the ceremony is under way and the couple has arrived at the altar.

1. Full-length images in back of church
2. Change lenses for existing-light image during the ceremony
3. Go three-quarters of the way down the aisle and repeat steps one and two.
4. Bride and groom lighting candles from back of church
5. Bride and groom kneeling, usually facing each other
6. Bride and groom kissing
7. Bride and groom returning down the aisle
8. Bride and groom returning down the aisle (have them kiss—a great shot!)

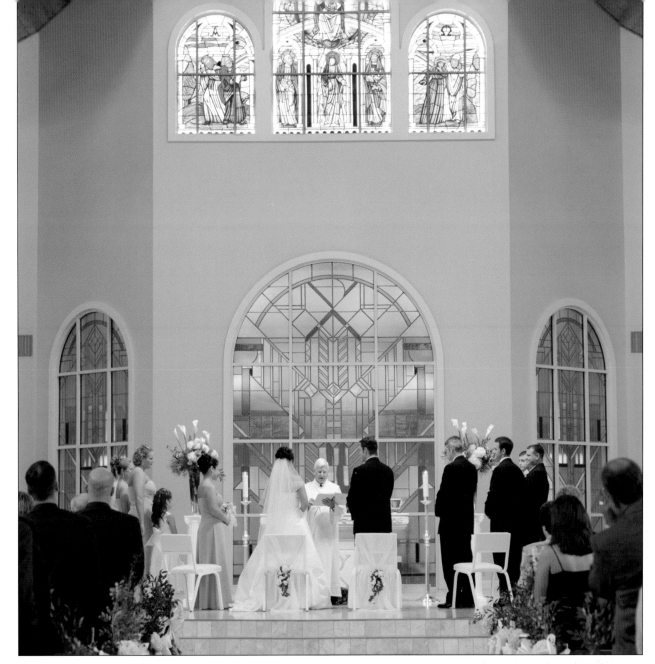

moment and distracts the audience. Instead I take my light meter along and use it. To work with the existing light within the church, I select Fuji NPH 400 film. This gives me the ability to shoot a shorter exposure.

● Lenses

I also shoot with several lenses during the course of the ceremony. The image above was shot with a 180mm lens. This is long enough to let me shoot from a discreet distance and fill up the frame nicely. I try to shoot four or five images from the balcony of the church (if there is one), then move down to the floor of the church and shoot from behind the guests.

● The Church

When working in a church that is not particularly attractive, I am especially careful with the lighting I use during the posed shots on the stage after the ceremony. If the altar is very dark, I may add light to it to give the images some flair. I also try out a variety of lenses. I may even back light the bride and groom at the altar to create some silhouettes.

CEREMONY VARIATIONS

● *Customs*

Although the major elements of most weddings are the same, you should talk with your clients about the characteristics of the planned ceremony. For example, when shooting a Jewish wedding, I have found that I have very little time to shoot. I may only get an image or two during the ceremony and a quick return trip to the altar. However, the bride and groom usually don't mind seeing each other before the ceremony, so I can get a lot of their photography done at this time. I can usually also cover the family groupings before the couple's ceremony begins.

● *Communion*

In the photograph to the right, the couple is taking Communion during their ceremony in a Catholic church. This is one of the most sacred parts of the ceremony, so I rarely shoot it. This church was quite lenient, though, so I was allowed to capture it.

● *Lighting*

The major guideline to follow when shooting a ceremony is to be totally unobtrusive. Yes, the couples want great photos, but not at the expense of their ceremony. This means never shooting with a flash, even if the church allows it, and not walking around during the ceremony. Take a few shots from the balcony, and a few from the back of the church, then wait until the ceremony is over and take the couple back to the altar to re-create the important parts of the ceremony. In addition to allowing the couple and

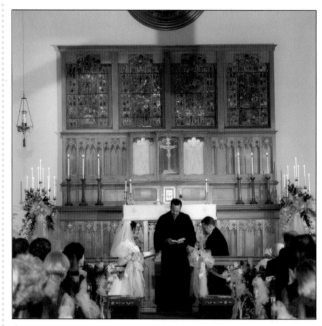

their guests to experience the real ceremony without distraction, returning to the altar will also allow you to set up the important shots carefully, light them properly, and create wonderful images.

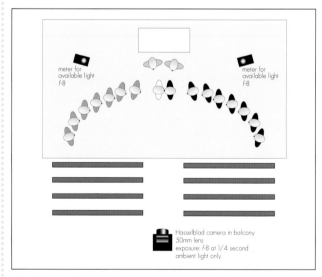

meter for available light f-8

meter for available light f-8

Hasselblad camera in balcony
50mm lens
exposure: f-8 at 1/4 second
ambient light only

Lighting diagram for image on the facing page.

RETURN TO THE ALTAR

Don't get overly stressed out about trying to fully document every little aspect of the ceremony as it happens. Rather, once the ceremony ends, have the couple and the minister return to the altar to re-create the desired scenes from the ceremony. This will allow you to employ a full range of camera positions and lighting options so you can get each shot just right. This is the best method for obtaining excellent images of the ceremony, since it allows you a full range of control.

● *Organization*

Aside from images of the couple at the altar, as shown on the facing page, you should also be prepared to shoot a variety of images of the bride, the wedding party, and the family at the altar after the ceremony.

● *Other Elements to Shoot*

If you are just starting out in wedding photography, I would advise getting to the church quite early and taking some shots. Set up a 3:1 light ratio and shoot close-ups of the altar, and any special arrangements or flowers and candles on it. You'll also want to get shots of the decorations in the aisle of the church.

You may also want to do some setup shots. Try taking a small table to a stained glass window (or regular window) and shooting a few arrangements of flowers (and/or candles) using window light.

One of the special shots we always do is of the candle that the bride and groom will light. To make it even more special, bring along one of the couple's wedding invitations and place it in front of the candle. For a nice warm effect, light the candle. Adding a star filter to this shot will give you another nice variation. One of these shots will make a perfect first page for the wedding album.

● *Timing*

Most churches limit the time for formals to about thirty or forty minutes. When things are going well, this is sufficient, but many unexpected things can happen. If anyone is late, you'll have less time to shoot before the ceremony, and will have to squeeze

MARKETING

Don't forget to make your images work for you! After the wedding, make a few extra prints of the photographs you shot of the floral arrangements and build a little album for the florist. Be sure to enclose your card, and present it to him or her. The florist can use your photos to sell his or her work to future clients and may, in turn, be able to refer clients to you. This is a great way to get some exposure at a low cost to you. Brides often rely on the opinions and references they are given by professionals in the wedding business, so making sure that churches, florists, and bridal shops are familiar with your work can be extremely beneficial.

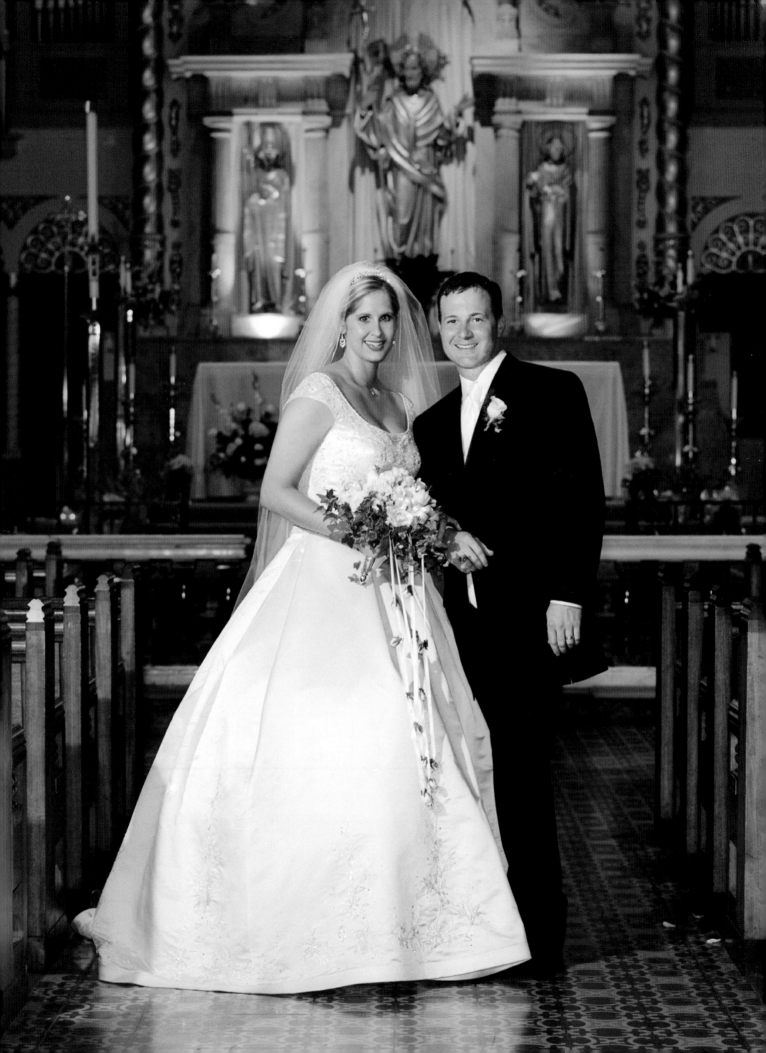

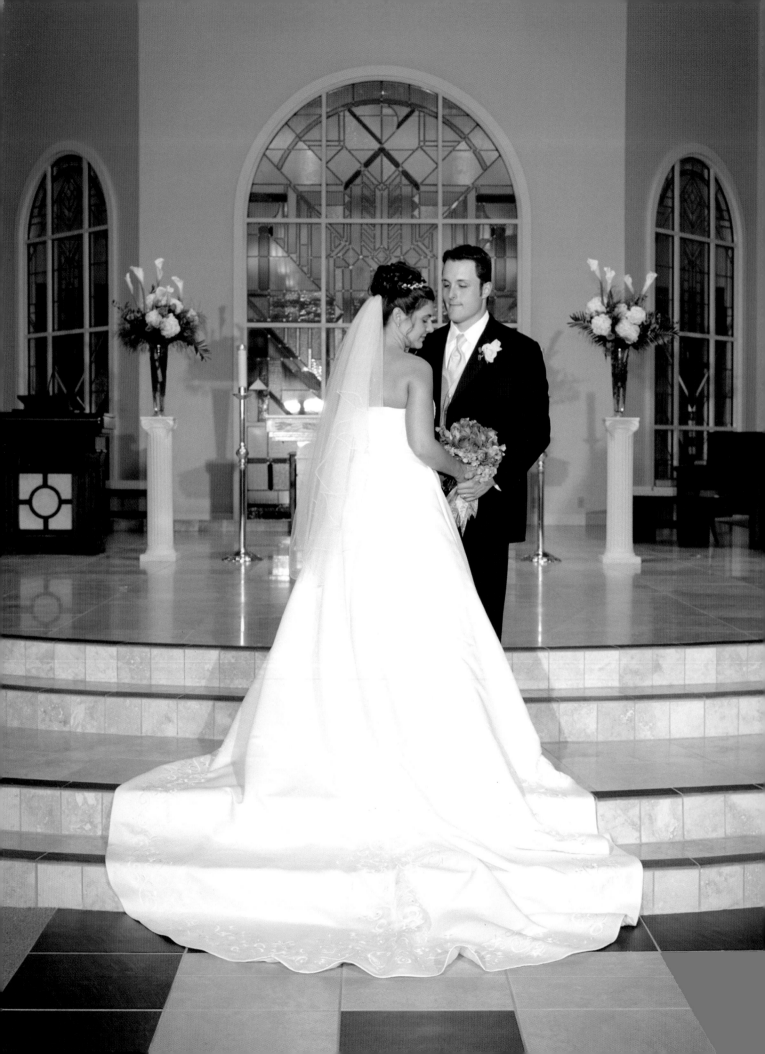

these images into the time allotment after the ceremony. To help organize and reduce the time needed for altar-return formals, ask the bride to assign someone in the family to make sure all of the family members and wedding party are ready and waiting in the church immediately after the ceremony. It helps if she chooses someone who knows as many of the participants as possible. Using a bride-appointed assistant to round up people will help to ensure that you are able to get all of the important images that the bride and groom expect.

● *Receiving Line*

We try to discourage couples from having a receiving line for several reasons. First, occurring right after the ceremony, it cuts into the time for formals. Second, it opens up the opportunity for too many accidents—Aunt Betty's makeup may get on the groom's shirt when they hug, the bride's makeup can be ruined, a high heel can accidentally go through the bride's dress, everyone may end up with lipstick on their cheeks, and if the weather is hot, everyone will be sweaty when they come back in for formals. Inform your clients, then let them decide.

● *Ideas for Photos*

The list below gives you some some ideas for your photography after the ceremony. You may find additional ideas for photographs, poses, and groupings on pages 116–18.

1. Reshoot some key moments with flash
2. Bride and groom on either side of minister (full length and three-quarter length)
3. Bride placing ring on groom
4. Groom placing ring on bride
5. Bride and groom kissing

BLACK & WHITE

Although color is still the primary choice of most brides and grooms, black & white images are also popular. This has been driven, in part, by the popularity of the photojournalistic style.

In addition to their "normal" presentation, black & white images can also be printed on colored paper or hand-tinted (either digitally or with traditional media) to create highly appealing products to supplement the color photography in a couple's wedding album. Very artistic handcoloring can create a beautiful and truly unique piece of art for the bride and groom.

An especially popular type of image is the sepia-toned black & white. With a very traditional and refined appearance, these images sell well as a supplement to color photographs. I would highly recommend having some samples available to show your clients. Again, these can now be created quite simply using digital imaging software like Adobe® Photoshop®.

3.
THE BRIDE AND GROOM

CREATIVE LIGHTING AND POSING TECHNIQUES FOR

TIMELESS WEDDING-DAY PORTRAITS

CAPTURING EMOTION

These images take a little bit more time to shoot. Yet, with careful planning, you can work efficiently and produce truly unique portraits.

● *An Elegant Pose*

An image like the one shown below is included in our photography of almost every wedding we shoot. The shot uses the groom as a prop and lets the emotions of the bride make a simple statement about the day. What's important about the day is the emotions. You don't always have to include big smiles to show this; sometimes you may want to portray the more subtle, intimate aspects of the day.

This is a simple pose to execute. Just bring the groom up close to the bride and have him wrap his arms around her. Next, position the bride in a profile and sweep the veil back from her face. She should be

DISTRACTIONS

When shooting wedding portraits keep a careful eye on what is happening in the periphery of the shot, as well as what's going on in the background. Any number of distractions can become a problem, from stray people, to coats left laying on pews, to cars passing an environmental shoot. You need to develop a sixth sense and work to catch distractions before they happen.

posed facing the main light source. With the groom in place, have him turn his face toward the light but continue to direct his eyes at the bride.

The image on the facing page is a variation on the same idea. Here, the groom is in profile and the bride's face is shown in a two-thirds view. Notice that her rings are also visible—an extra reason for the couple to love the image!

● *Feelings*

When you're working with subjects on an emotional photo, you need to cultivate the mood you're looking for. Talk in a soft voice. Ask the couple to think about the day they first met, or about what this day means to them. This is such an emotional event for the bride and groom, you may even see a tear or two. What could be better than immortalizing such profound human emotions? It's one of the things that makes me feel proud and lucky to be a photographer.

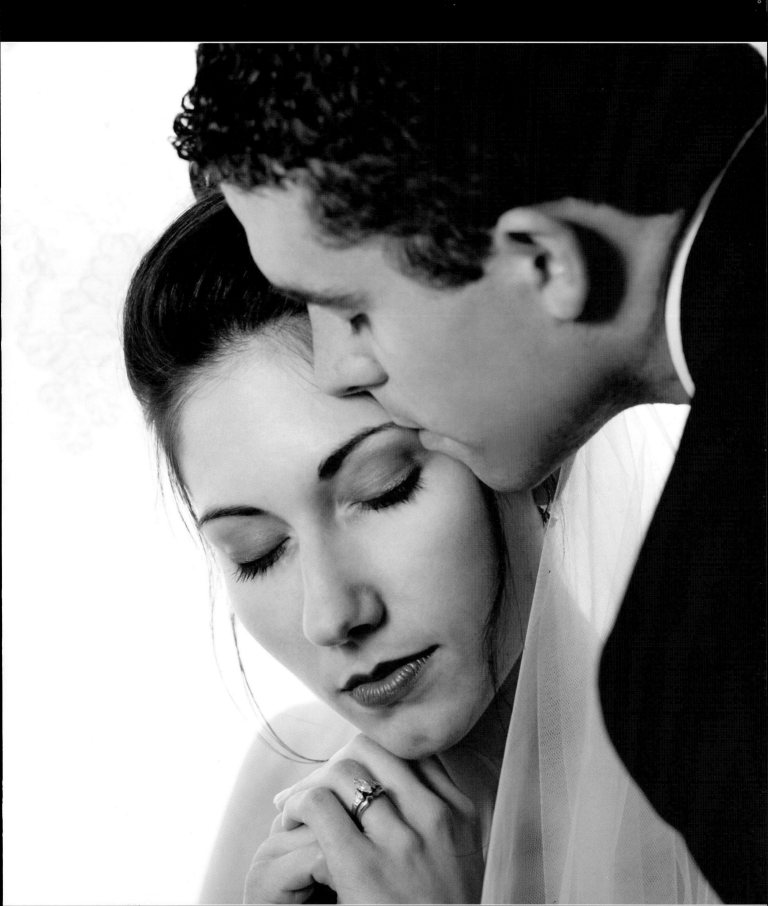

THE FIRST TIME, EVERY TIME

Although you may shoot dozens, or even hundreds, of weddings every year, you should remember that for your clients, their wedding is a totally unique event. While the newlyweds will value you for your experience, they will also appreciate that you show enthusiasm for their special day. Treat every couple with the same care, attention, and concern that you gave your very first client.

● Lighting

This is a very well-lit room. There is light from the windows behind the couple, as well as from overhead light fixtures on the ceiling. The light overhead gave me an instant hair light for this shot, adding sparkle and highlight to the couple's hair. I metered for the

QUALIFYING THE CLIENT

A wedding photographer's net cost has many components to consider. Thus, it is important that you put some thought into your pricing and have a definite plan down on paper. Avoid quoting prices over the phone—clients who demand a price over the phone are shopping for price alone, not for the quality work that you can provide. Instead, tell them that you would be happy to provide them with a price list and suggest that they stop by or make an appointment to see your work. This is called "qualifying" your client.

overhead light, then used a Quantum bare-bulb flash on a radio slave to the right of the couple and placed very high. This bare bulb combined with the ambient light to produce very nice highlights.

● Posing

This is a traditional pose for the bride and groom—one I try to shoot at every wedding. It's fairly simple. First, place the bride. She should stand with her weight on her back foot and with one shoulder slightly lower than the other. Her face is then turned toward the higher shoulder. The groom is brought in behind the bride. Notice how the groom's body is half covered by the bride's. This makes the pose flattering even for a heavy groom.

POSING FORMALS

● Formals

Formals are the part of the wedding photography for which you need to reserve the most time. They are also images for which you need to keep a particularly careful eye on the design, perspective, and details. Examine the lines of your subjects and the elements in the background. I like fluid lines and tend to look for S-curves. I also like images with perspective, so I am very fond of including architecture in my wedding formals (for more on this, see page 66).

● Details

I urge you to take the time you need to pay close attention to the details. Little things like a not-so-perfect veil, a crooked tie, or the stems showing on the bouquet can ruin an otherwise beautiful portrait. They may not seem like much, but the details can make or break your image.

● Posing

I like to put a little "dance" in my poses—a sense of swing or movement that makes the photograph a more natural and vivid portrait. After all, if you are looking for elegance in your images, why would you want poses that just make your subjects look stiff? Be confident when instructing couples on poses you are looking for. Your confidence will assure them that they are in good hands and will encourage them to put their trust in you.

● Albums

Once you have a selection of sample images to show prospective clients, invest in some sample wedding albums. Don't just go for the most expensive ones in hopes of impressing your high-end clients. Rather, put together a range of albums, ensuring you will have samples to show clients with various budgets.

WORKING WITH AN ASSISTANT

An important duty of an assistant is to make sure that all of the equipment is accounted for throughout the day. An assistant should also be trained to help with lighting, metering, and styling the bride's dress and veil. I have always trained my assistants to become wedding photographers themselves someday.

As you work with an assistant, you should develop something of a secret language of key words and hand signals that will allow you to communicate efficiently with each other without disturbing your clients. For instance, if I think a light is malfunctioning, I will give my assistant a particular expression. He may then reply, "Ambient light." This lets me know that the exposure was correct, but the flash did not fire. If this happens, I simply go to the bride and spend a few moments styling her dress or fine-tuning the posing while my assistant fixes whatever was wrong with the light. Then we can continue.

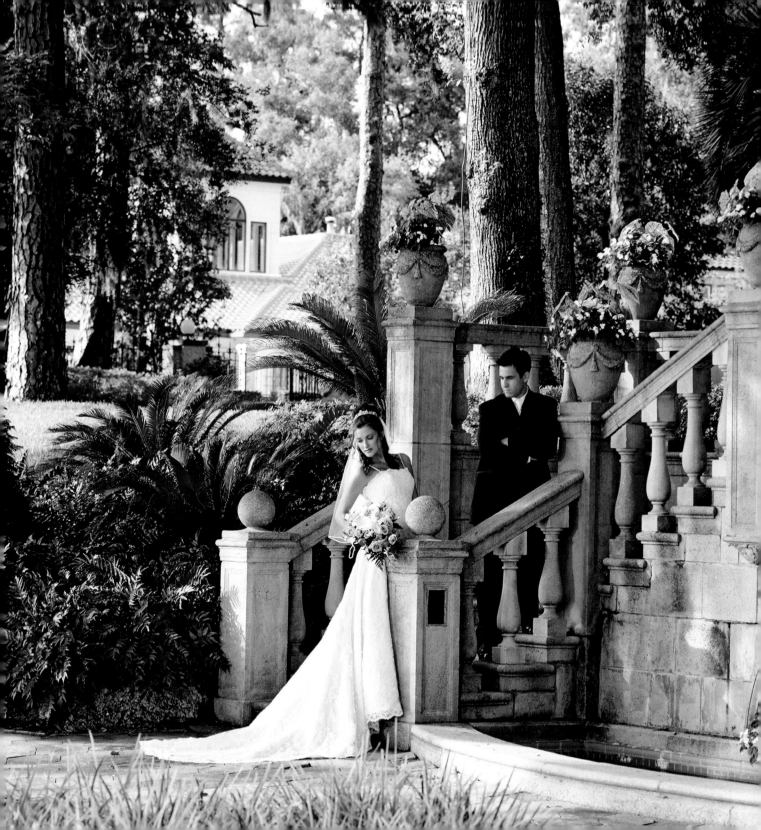

SIMPLE VARIATIONS

Three portraits are provided here with very similar posing. The couple below was posed for the full length shot (left), then we moved in for a tighter image (right)—two variations from one basic pose.

● *Lighting*

In the images below, the bride was posed in profile facing the main light source. The groom was then brought close to the bride with his arms around her. In the portrait on the left (below), the light hits the groom's face at about a 90-degree angle, creating a soft, split-light effect (half of the subject's face in light, half in shadow). In the portrait on the right, the groom's face was turned more toward the light, although he is still looking at the bride. This turn of his head allows more light to fall on his face, creating a Rembrandt lighting pattern.

● *Styling the Dress and Veil*

The dress and veil are important and symbolic parts of the wedding day. You should take care to treat each gently and style them with care for every image.

The basic principle for styling the gown is to make sure that it falls in smooth, natural curves and is never allowed to become bunched.

For the veil, you should also make sure it falls smoothly and naturally without hitting any obstructions. You should also try to arrange it so it falls as straight as possible.

The full-length portrait on the opposite page incorporates the beautiful architecture of this arch in a bridal portrait. Notice how the bride's fluidly curved pose complements the other curved lines in the composition, and how her dress falls smoothly and naturally.

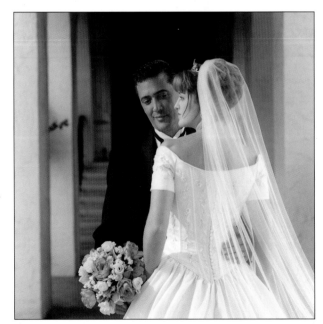

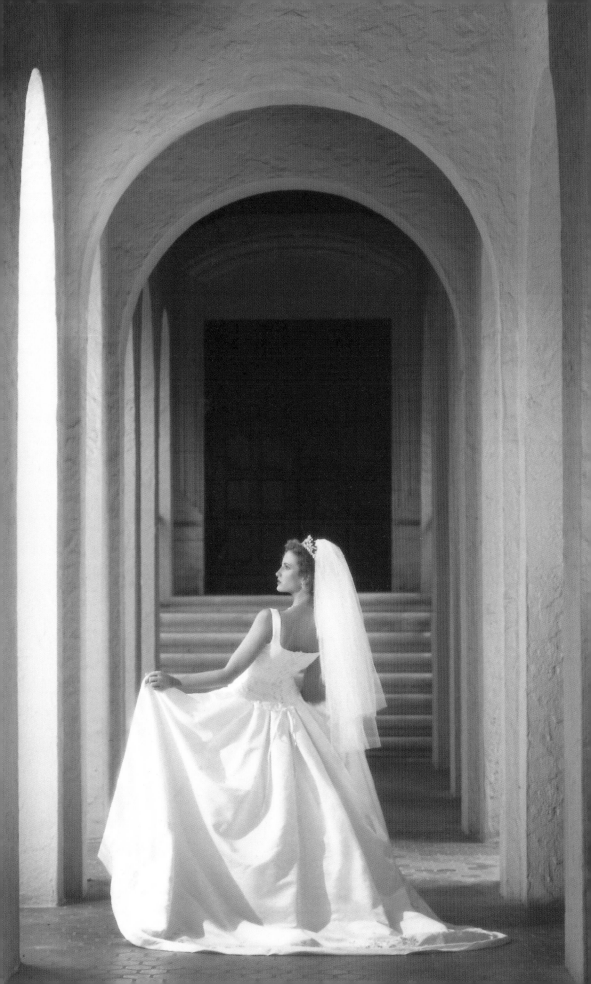

THE VEIL AS A PROP

In these images, the veil surrounds the closely posed couple as a symbol of their wedding day. The dress has other great applications as a prop; to read more about these, see page 14–19.

● *Tilt*
For the top image (right), I simply tilted the camera to add another visual element to the composition. Using a centered composition paired with this tilted element creates strong impact and a dramatic feel.

● *Photojournalism*
Photojournalistic coverage simply means covering the wedding with artistic candid images. Most of my clients still enjoy traditional wedding photography, but photojournalistic coverage is also very popular. Therefore, I try to do some of both. Keep your eyes open for opportunities to capture candid moments at every wedding.

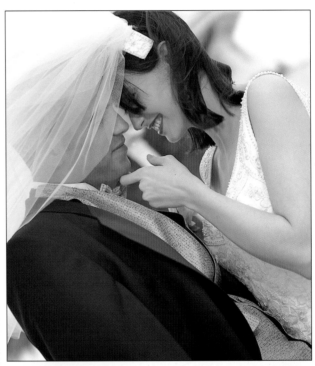

HIDING HANDS

Sometimes you may come across a bride or groom that does not have particularly attractive hands. Since many wedding images feature the hands (and especially the rings), you need to have a strategy for dealing with this. The secret is coverage—use the bouquet, or gloves, or even a hat. For ring shots of the couple, use the most attractive hand over the less attractive hand.

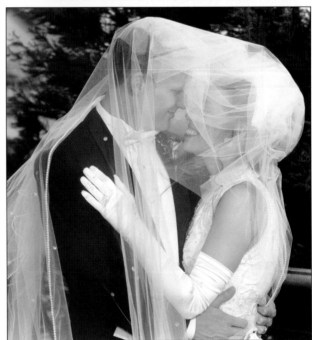

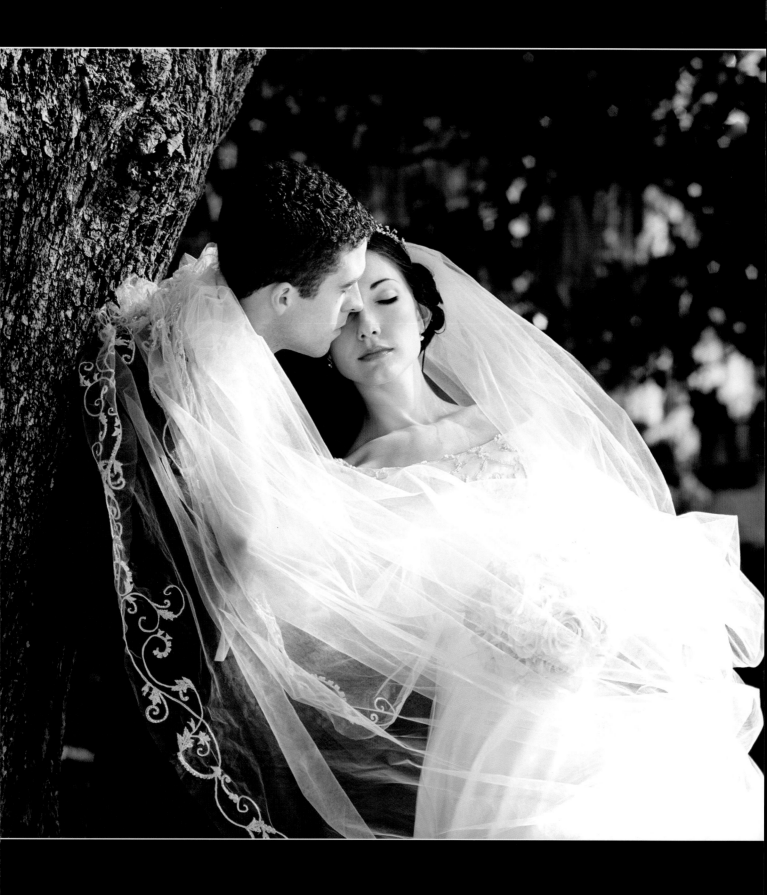

IN THE AISLE

● *Location*

With repeated shooting at a site, you have a wonderful opportunity to get really comfortable with the unique light characteristics and special features of the setting. This allows you to build a repertoire of shots that you know will work perfectly. The two shots shown here represent a basic image we do for just about every wedding.

● *Composition*

You should always look carefully at the lines of your subject. Here, the composition begins with the diamond shapes and rectangles of the church's architecture. The subjects were then posed with an eye to curves. This creates a contrast between the massive architecture and the subjects, which are comparatively small within the frame. The beautiful lines of the architecture draw your eye through the image, but the curves of the couple's posing create a contrast that keeps them from being overwhelmed by the architecture.

● *Hand Posing*

The posing of the couple is made more polished by the careful attention paid to their hands. The groom leans back on a pew with one leg crossed over the other. It's a relaxed pose that looks natural. His hands are placed casually—one at the pocket of his trousers, one on the pew in front of him. The bride holds her bouquet gracefully, with one hand draped lightly on the pew in front of her. The scene was fine-tuned from the balcony, where I shot it. I firmly believe in evaluating a scene through your lens before considering it set.

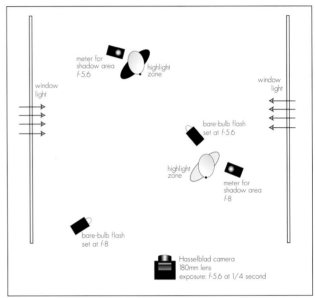

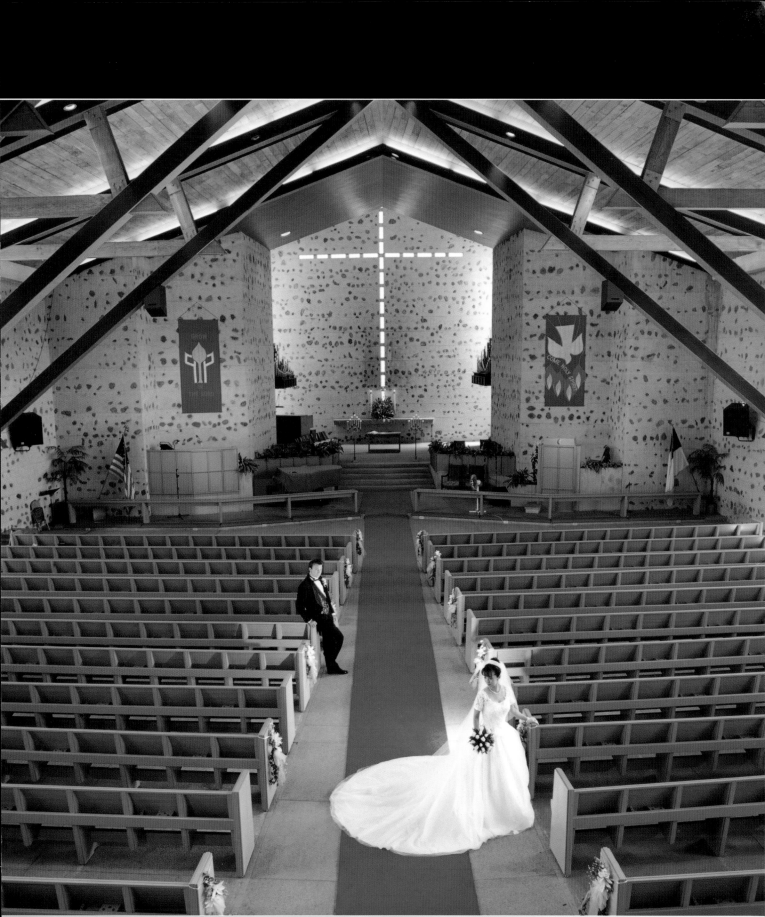

ENVIRONMENTAL IMAGES

To help couples decide on whether they want environmental portraits and where they'd like them taken, I display sample images from various appropriate locations. The images show the sites at various times of day (especially important for nighttime existing-light shots).

Whenever discussing environmental portraits, it is important that you stress to your clients that these images do take some extra time for you to set up and shoot.

● *Bad Weather*

In case inclement weather should make your chosen location inaccessible, you should also make a point of discussing alternate plans with the bride and groom.

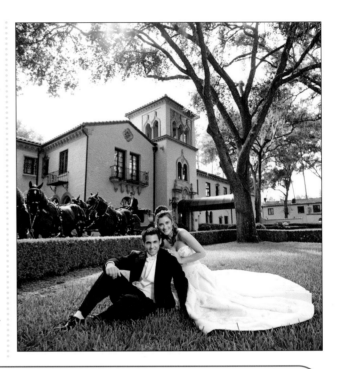

THE ROMANTIC SESSION

Not all couple's ceremony or reception locations are the best environment for beautiful romantic images. Therefore, we offer a "Romantic Session" in addition to the engagement and bridal sessions that we provide for our clients.

The "Romantic Session" can be done before or after the wedding day (depending on the preference of the couple) with the bride and groom dressed in their wedding attire and going to a beautiful location of their choosing. (Sometimes it is better to do the session after the wedding so that the bride doesn't have to worry about getting her dress dirty.) This is a great way to capture the real relationship between bride and groom, because they are relaxed and don't have to deal with the stresses that the wedding day brings.

At the session, we have the time we need to make the couple comfortable and create some truly romantic images. It's also a great opportunity to suggest all of the fun photographs that there just is not time to capture on the wedding day—like walking down the beach barefoot, going horseback riding, or dancing in the moonlight. This session provides images that are a wonderful addition to the couple's wedding album and can generate additional sales.

Explain to them before the wedding that you can't perform miracles where the weather is concerned, but in the event of problems, you will take them to a particular alternate location and do some other poses. Let them know you have a solid contingency plan and that they will still get great images.

● Timing

The usefulness of a particular location can change throughout the day and from season to season. In Florida, where I live, there aren't too many seasonal changes to worry about aside from rain. In other climates, the changes can obviously be quite profound and are something to take into consideration when planning environmental portraits. You should also consider the time of day and think about the kind of light you will be working with. The traditional "golden hours" of early morning and late afternoon provide the most desirable lighting conditions, but be prepared to shoot throughout the day, and have strategies in place for working with natural light.

● A Favorite Location

As you shoot more and more weddings, you will find favorite locations that you know will reliably produce stunning images.

THE RINGS

● *Three Ring Exchanges*

The ring exchange is one of the most symbolic parts of the ceremony. As such, it's something I want to make sure to capture fully. I start by photographing the actual ring exchange during the ceremony, then go on to shoot the exchange two more times after the ceremony.

The second ring exchange shot occurs on the return to the altar after the ceremony. Here, I re-create several important moments from the ceremony, but shoot them from the angles and with the lighting equipment that would have been too disruptive to use during the ceremony. See pages 36–39 for more information on this phase of the shoot.

I also like to go on to shoot a final series of ring exchanges outside while we are doing other environmental photography.

● *The Outdoor Exchange*

Outdoor ring-exchange shots are popular among my clients—I recommend you offer them to yours. I shoot full lengths, three-quarter lengths, and close-ups (which look especially nice in an oval mat). For the image below, I started with the groom in profile and the bride in a two-thirds pose looking down at her wrist. I shot the image with a telephoto lens to let the background go totally out of focus. Be sure to have the bride bend her wrist slightly, or ask the groom to put a little pressure on it. This will give the bride's hand a very feminine look.

● *Additional Shots*

Now that you have the bride and groom in a nice pose and lighting situation, try some variations. Some ideas are shown on the facing page.

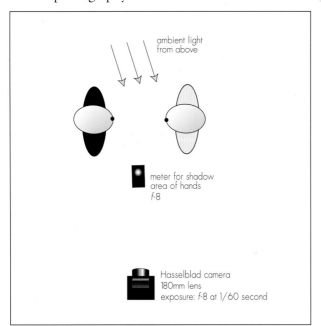

ambient light
from above

meter for shadow
area of hands
f-8

Hasselblad camera
180mm lens
exposure: f-8 at 1/60 second

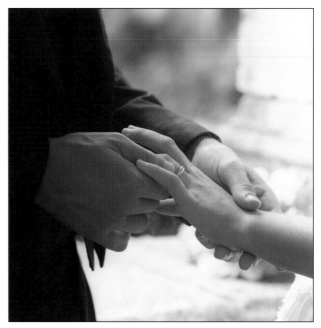

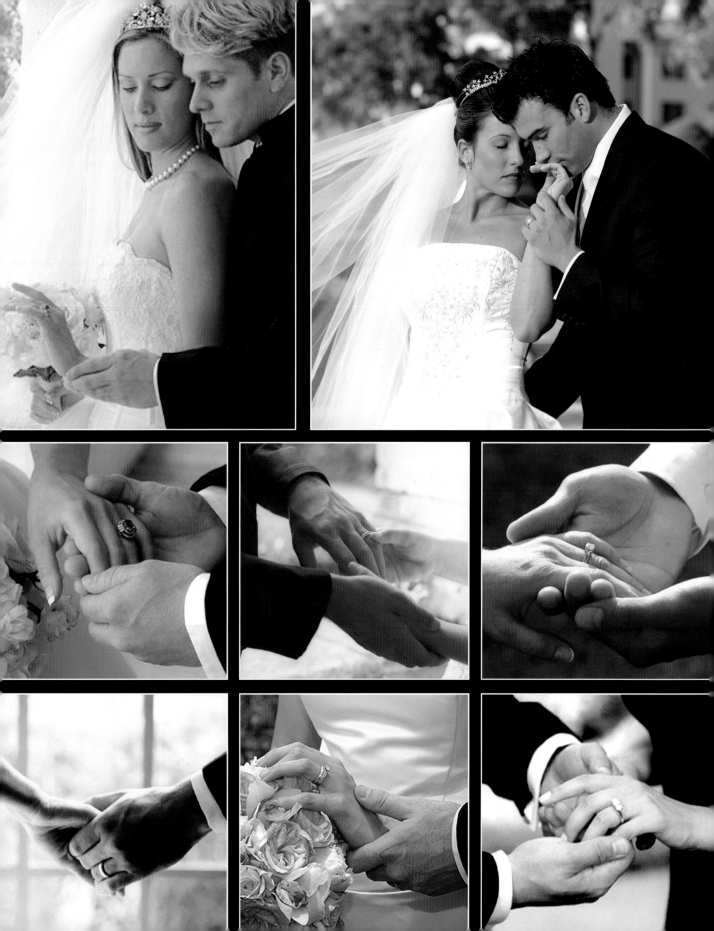

WORKING WITH GROOMS

Working with grooms is different than working with brides. For one thing, grooms are sometimes less cooperative. Like the bride, the groom is facing many stresses on this important day. He is leaving behind single life, he's nervous, he feels the pressure of being in the spotlight, and to top it off, he may even have a hangover from celebrating with friends the night before. Whatever the cause, if a groom seems nervous, the first thing I do before shooting is try to get him comfortable. I'll take him on a little walk and get away from the groomsmen. I also try to engage him in a conversation about sports, business, travel—anything other than the event at hand.

● *A Tough Shoot*

I think that the weddings that have been the most difficult for me have been those when the groom and groomsmen show up drunk. The wedding may be thought of as the bride's day, but the groom is half of the event, and when he's not in good shape it can be difficult.

In this situation, you still have to work with the guys. You know what you have to do, even if they don't want to pose at all. Somehow, some way, I have always managed to get them to cooperate, but it's a situation where you'll have to be creative and think on your feet.

One good line of reasoning that seems to make an impact is to remind the groom that he has invested a lot of money in your work and you're sure he wants that to pay off with a great wedding album. You may also want to remind the guys that the sooner they let you get your job done, the sooner you will be able to send them on to the reception.

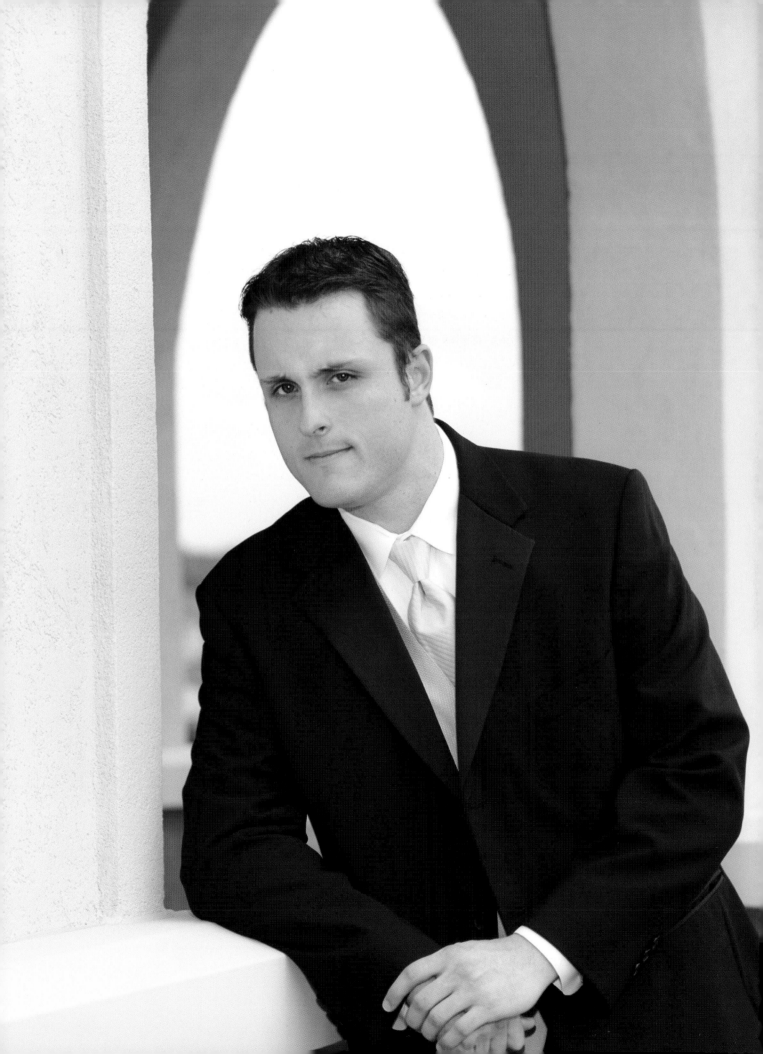

DELICATE CURVES

● *Awards*

I'm very proud of this image, called *Delicate Curves*, which was named a Professional Photographer's Association (PPA) Loan Print.

● *Posing*

Putting dance into your posing is a great way to separate your work from the competition. The concept is one I learned from Stephen Rudd, an internationally known photographer, and is one that has really revolutionized and added life to my images.

Notice the graceful curves of the bride in this image. The pose was accomplished by having the bride put her weight on her back foot and bend

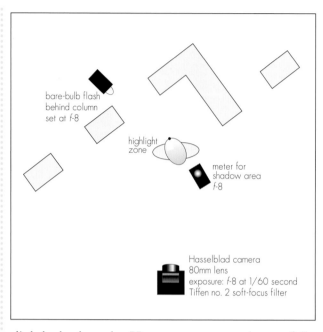

slightly backwards. Her arms are posed gracefully behind her back and her wrist is bent slightly, creating a very feminine curve.

● *Location*

This arch was selected because it was wide enough to accommodate the full skirt of the dress. In the original image, several arches were visible to the left of the bride. These were cropped out to leave the bride in the right third of the image.

● *Light*

This is a perfect example of how beautiful overhang light can be. I metered for the shadow side of the subject, then set the bare-bulb flash. This was positioned outside the columns and placed very high. It is a simple lighting setup, but effective and elegant.

THE WEDDING PARTY

Whether you are just getting started in wedding photography or are a working professional, building good relationships with other wedding service providers (such as bridal boutiques, caterers, reception venues, and florists) can provide many advantages. For instance, one of the most extravagant bridal boutiques in Orlando allowed us our choice of gowns to produce some of the images in this book. Doing a few shoots with models and borrowed gowns (then providing the shop with photos in return) can be a great way to promote your business and build your portfolio. It's also a great way to practice new image concepts and build your skills.

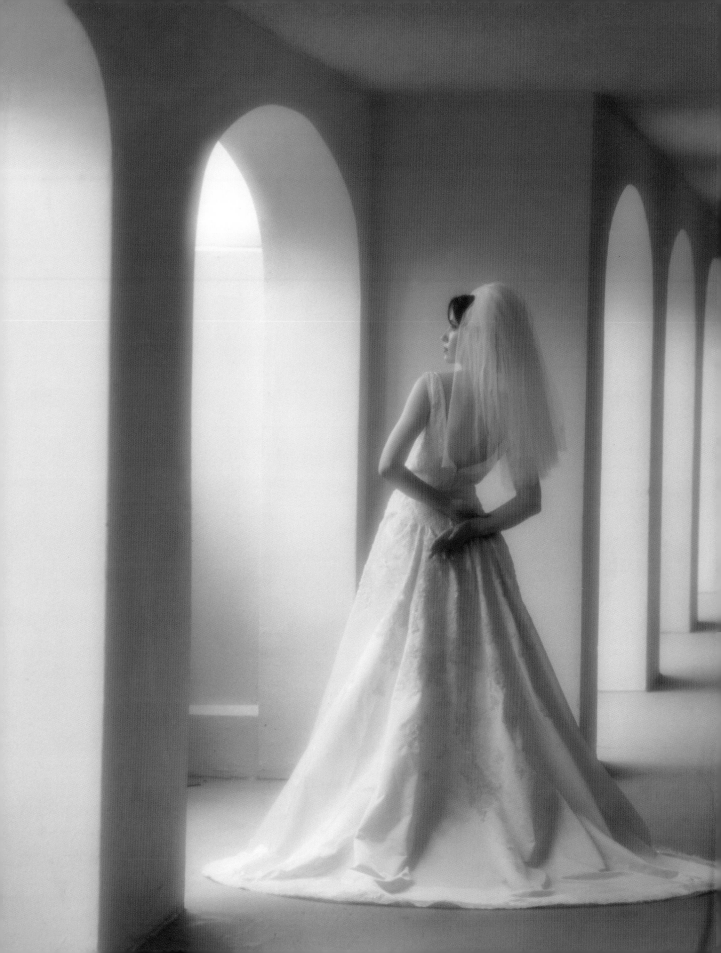

CAMERA ANGLE

● *Composition*

The portraits you create are the way you make your statement as a photographer and an artist. Therefore, you should be conscious of the message you are creating every step of the way.

In this image, the natural and elegant composition make just the right statement about the bride. The veil was styled to fall neatly away from the face, creating a look that is soft but not fussy. The flowers are in frame but kept in the lower part of the photograph so that they do not overwhelm or interfere with our view of the bride's face. The bride herself was posed with her face at about 45 degrees from the main light. This creates the classic Rembrandt lighting pattern (indicated by the triangular area of light on the shadow side of her face).

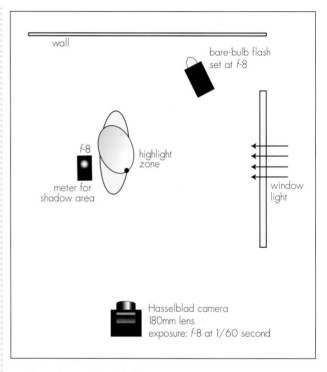

FLOWERS

The bouquet is a special part of the bride's attire and an important prop for your photography. Treat it with care. You may wish to shoot it in different areas—in the bride's hands, cradled in her arms, sitting on a nearby ledge, etc. Wherever you place it, be careful to conceal the stem area—this isn't the prettiest part of the bouquet. Be sure the bride holds the bouquet gracefully and naturally. When the bouquets are used in group shots of bridesmaids, make sure all the women are holding their bouquets in the same way.

● *An Elevated Position*

Although it's barely noticeable, I have photographed many of these bridal portraits from an elevated camera position. All of the brides featured in this book are trim; nonetheless, shooting from slightly above eye level helps to eliminate any hint of a double chin. For brides who are overweight, shoot from a slightly higher angle and have them look into the camera. Tilting the head up will make the skin look firmer.

Remember, it's your job as a wedding photographer to work with people's emotions on the biggest day of their lives—every wedding is a once-in-a-lifetime event. Brides want portraits that make them look beautiful. Do anything you can to show them at their absolute best.

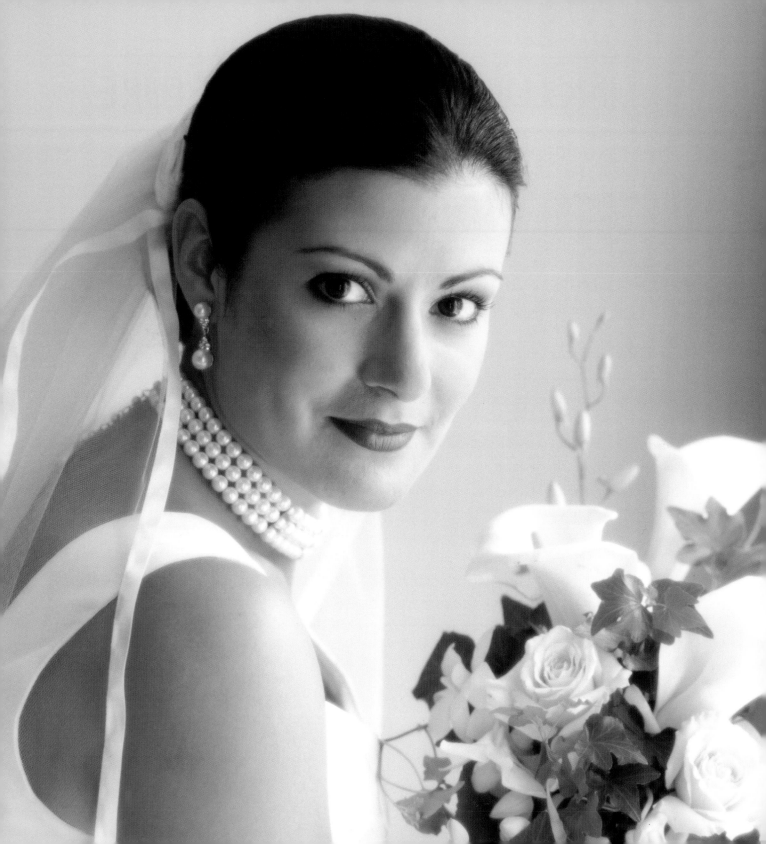

INCLUDING ARCHITECTURE

Architecture can add a beautiful element to wedding photography. Throughout this book, you will find examples of subjects posed with windows, fireplaces, in wide views of the church, and (a favorite of mine) in archways. Adding these elements to your images can help you set a mood and employ appealing lighting. Additionally, it will set your work apart from that of your competition.

● *Composition*

I love to use a lot of perspective in my photography. This shows in compositions such as the one presented on the opposite page. The bride is placed prominently amidst a deep field of beautifully carved stone archways. Notice how the heavy texture of the architecture contrasts with the smooth, soft curves of the bride's gown and delicate veil.

To compose a strong image amidst architecture, I start with the architecture. After all, you can't change that element and must therefore adapt what you *can* control (subjects, camera position, etc.) to

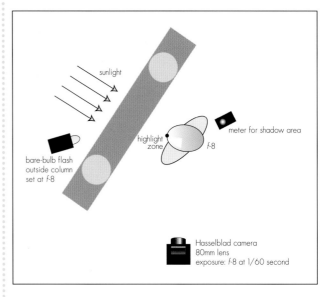

work within it. With careful attention and practice, you can develop a good idea for scenes that will accommodate your subjects well, and a sense of how best to pose them.

● *Location Scouting*

If you decide to do architectural wedding images, take the time to scout out some nice locations and test them out. Before you take a couple to the location, you should already have a few images planned and tested.

Above all, when working with a client on images like these, allow yourself ample time. You will need to employ careful posing and lighting and will want the chance to work on several variations at the location of your choice.

KEEP IT MOVING

When working on environmental portraits with groups, time is especially valuable. This makes it especially important to know how to set up simple poses and lighting that will yield consistently beautiful results. Remember to keep up the pace—groups will get restless if you don't keep things moving along!

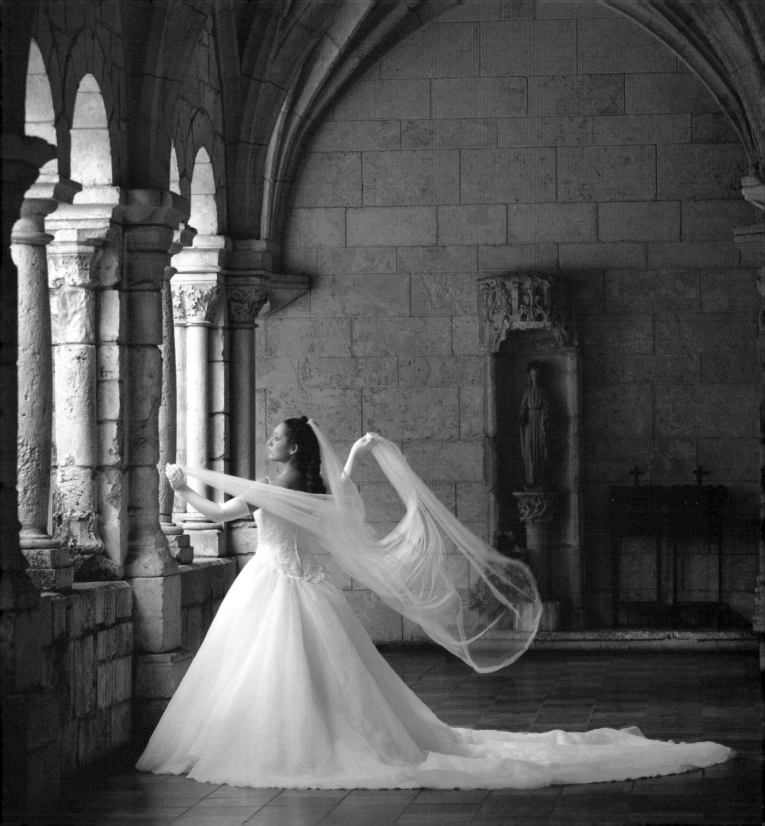

BARE-BULB LIGHTING

● *Indoors and Out*

Bare-bulb flash lighting gives you a subtle way to add another layer of light in the highlight zone and open up the shadow area. It is a versatile technique with applications both indoors and out, and with many qualities of light.

In the photo to the right, you can see how bare-bulb lighting provides nice highlights and opens up the shadow areas. On a totally cloudy day with very flat lighting, bare-bulb flash can also provide more directional light and produce the shadows needed to depict shapes and textures. In the image on the facing page (as well as the one on the previous page), the flash was placed outside the wall of stone columns. Because bare-bulb light is undiffused and emanates from a small source, it looks very much like sunlight. This makes it ideal for punching up the lighting in these images while maintaining a natural look.

On a beautiful clear day with lots of sunshine, you can pose your model with the sun behind him or her and use the bare-bulb flash to match the exposure on the front of the subject to the area behind.

● *Metering for Backlighting*

I always get questions about metering for back-lit subjects when combining ambient light and bare bulb. Here's how to do it:

First, set your incident light meter to "ambient." Then get close to the shadow area of your subject and take a reading. Let's imagine that this reading is

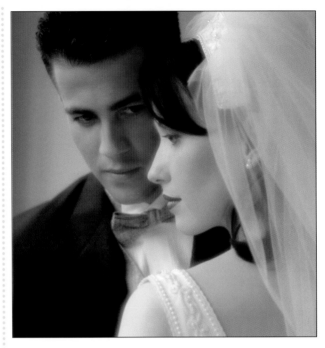

$\frac{1}{125}$ second at f8. Your goal will be to bring in light to open up the shadows, so you bring in flash.

Next, meter for the flash only. Set your meter at $\frac{1}{500}$ second and the correct ISO setting, and set it to "non-cord." If you don't have the meter set on $\frac{1}{500}$ second, you'll drag in ambient light and won't produce the proper exposure. With your sender in hand, hit the test button toward the bare-bulb unit. Set to $\frac{1}{500}$ second, the meter will only recognize the flash that is being recorded.

To create the best overall best exposure, you will then set your flash unit to one stop less than the ambient reading. You can do this either by adjusting the flash unit to the proper setting or by moving your light backwards or forwards to add light to open up your shadows.

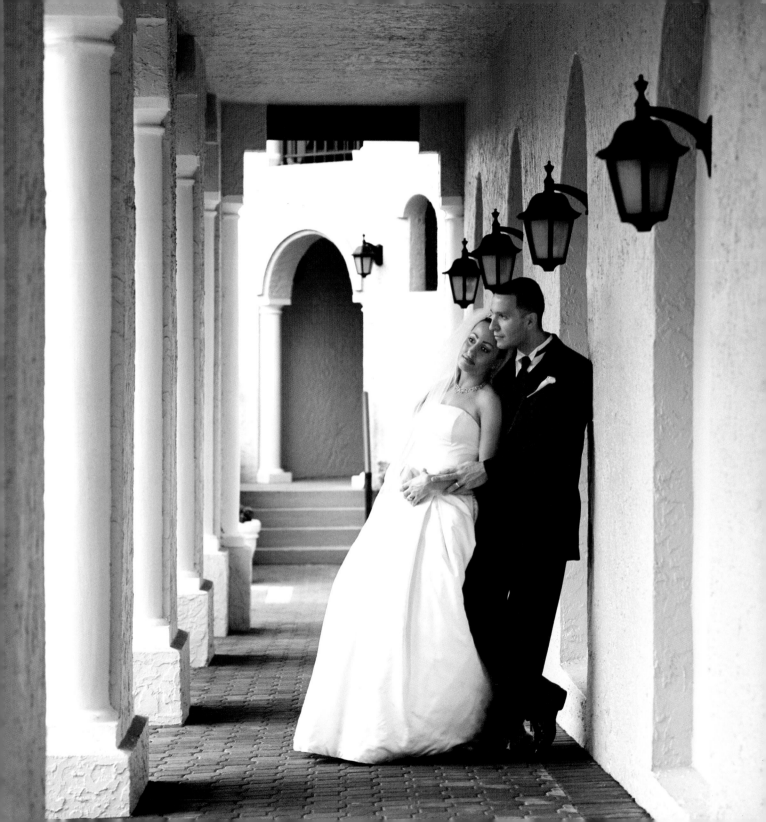

STYLING THE GROOM

● *In the Gazebo*

For the pose shown below, the groom was seated in a picturesque gazebo with his body turned away from the light, which came from the left side of the frame. When using a seated pose, make sure to have the groom sit straight and tall—slouching will look terrible. For the image below, the groom's face was turned into the light, and his hands were carefully posed. Having him hold his gloves (or jacket, as shown in the image on the facing page) gives the groom something to do with his hands and adds a nice detail to the shot.

Getting the location right was a little tricky. I wanted to pose the groom in an area where I'd be able to show part of the gazebo in which he was seated in the foreground, but also include another gazebo in the background to add a sense of depth and perspective. In order to get the right angle, I had to stand on a four-foot stepladder. This put me on a more level angle with the groom. One of the aspects of this shot that I especially like is the way the tree branches sway into the frame.

When you set up a shot like this, consider adding the groomsmen in the background and out of focus. Or, add the bride, looking lovingly at her new husband. Adding these subjects to the background and allowing them to go out of focus could create a very dramatic series of images.

● *A GQ Shot*

When setting up a shot like the one on the facing page, I have my assistant do the styling. We call this a *GQ* shot—a stylish shot with a little attitude created by having him throw his coat over one shoulder.

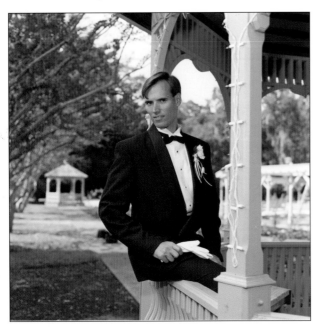

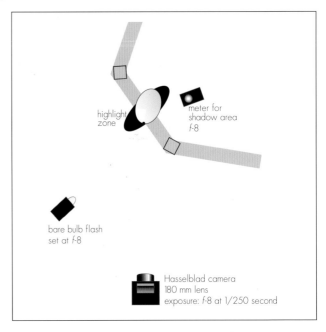

highlight zone

meter for shadow area
f-8

bare bulb flash set at f-8

Hasselblad camera
180 mm lens
exposure: f-8 at 1/250 second

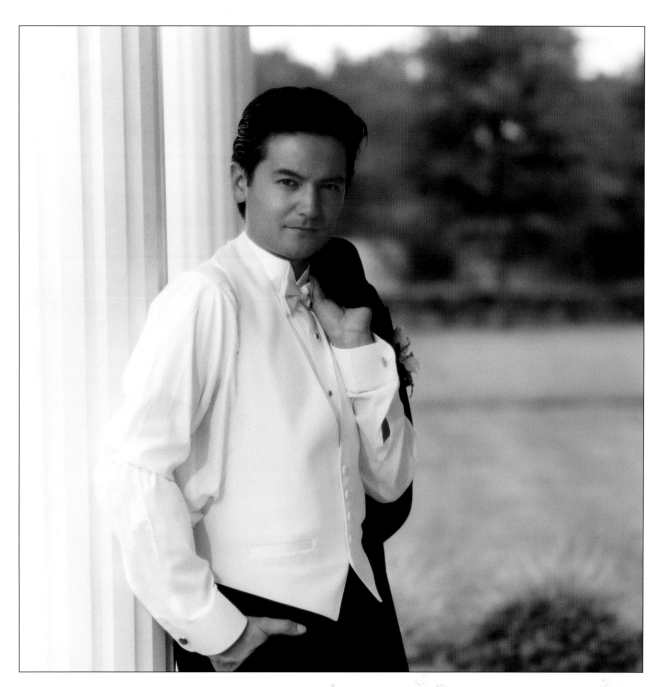

As in most of my shots, the subject is not placed in the center of the frame. This lets the row of columns lead your eye to him and makes for a more interesting image. Additionally, the extra space to the right side of the frame gave me space to move some additional subjects in and out of the frame without moving the groom. For one shot I added the bride, looking at her husband and slightly out of focus.

Another great shot was done with the parents in the right half of the frame, and also out of focus. You could even pose the groomsmen back there, and have them casually looking at each other for yet a different feel. Keep your eyes open for situations in which you can do several images without having to set up all over again.

POSITION, POSE, LIGHTING

● *Location*

The portrait on the facing page was created on the reconstructed grand staircase of the Titanic. If you've seen the movie *Titanic*, you'll recognize this as the location of quite a few chase scenes and grand entrances. As you can see, it's also a stunning location for a bridal portrait.

● *Basic Posing*

With the bride in place on the stairs, this elegant pose was simple to create. The bride arched her back slightly and placed her weight on the foot farthest from the camera, causing that shoulder to drop slightly. Then, she simply turned her face toward the higher shoulder. The next step was to pose her arms and hands gracefully.

● *Hand Posing*

Don Blair, one of my mentors, told me once that a portrait is not proper until the hands are posed correctly. In this case, both of the bride's hands were posed to create a classic S-curve. Notice how the wrist of her right hand is bent slightly, elevating the fingers and creating an elegant, feminine curve.

● *Styling the Gown*

Brides spend a lot of money to look their best—and a big chunk of that is spent on the gown. Because of this, it is important to make it look beautiful. Here the skirt was fluffed so that it fell cleanly and naturally, and the train was draped down the stairs to display its delicate scalloped edge. The images below show a similar attention to detail in the pose and styling.

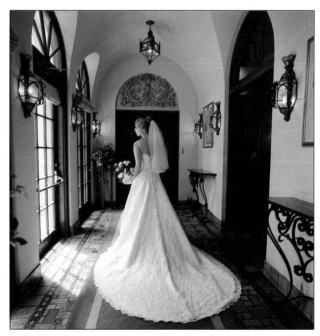

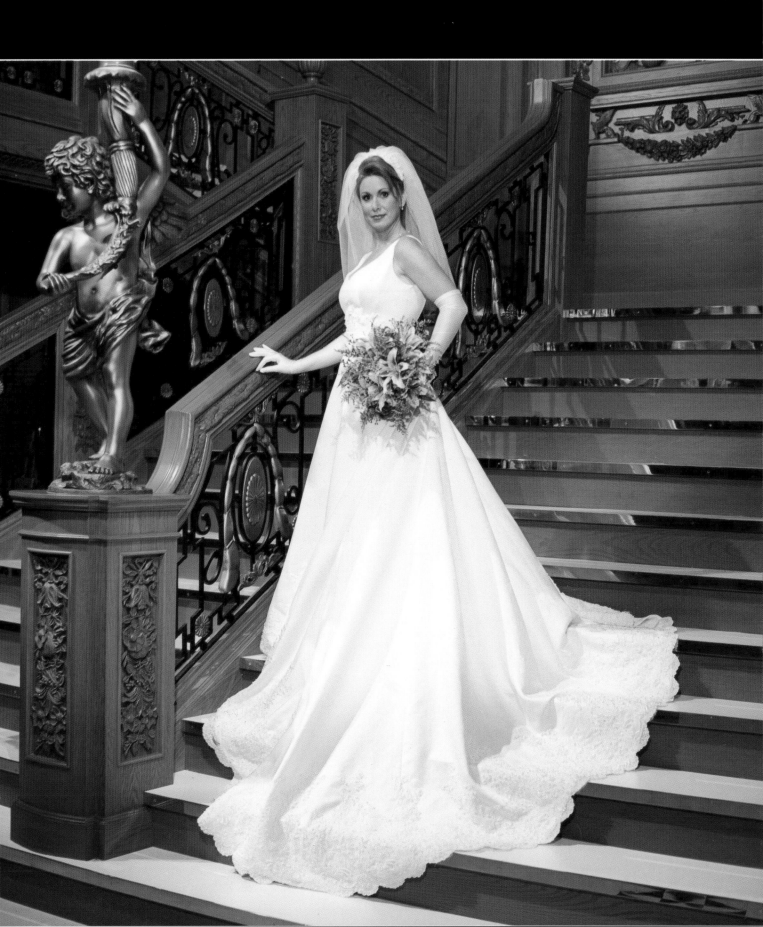

SILHOUETTES

A well-executed silhouette can be tremendously meaningful and elegant—and our clients love them.

● *The Technique*

Silhouettes can be accomplished anywhere you can create a strong contrast in light levels between the couple (in lower light) and the background (in higher light). You can do them outdoors against the sky, inside against stained glass, or in an open doorway.

You can meter for the background for a perfect silhouette, as shown in the top-right image. Or, to retain a little detail on the subjects' faces, you can meter off the highlight area of the face, as shown in the bottom-right image. Notice the beautiful triangle of light this creates on the bride's cheek.

● *Composition*

The key to silhouettes is not to overdo them. Keep to simple subjects, like the newlyweds posed in an elegant profile.

Look for pleasing shapes and simple, dramatic poses. Try having the couple kiss, or have the groom look into his bride's eyes and place his hand on her chin. You should also try something like the full-length image on the facing page, where a sense of dance was added to the couple's pose. Notice how beautifully their fluid lines set them apart from the solid linear frame of the columns that flank them.

As you experiment, you'll probably come up with more interesting locations and poses for silhouettes. I definitely recommend giving them a try.

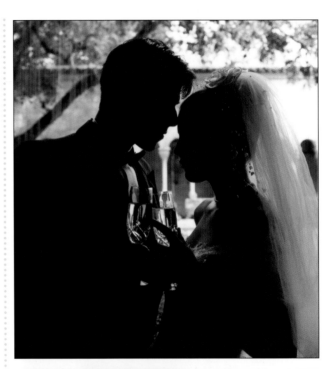

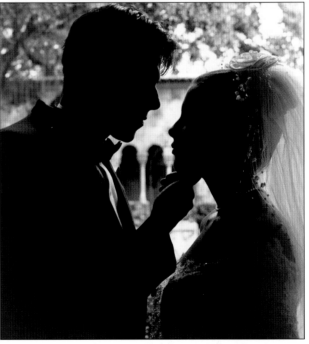

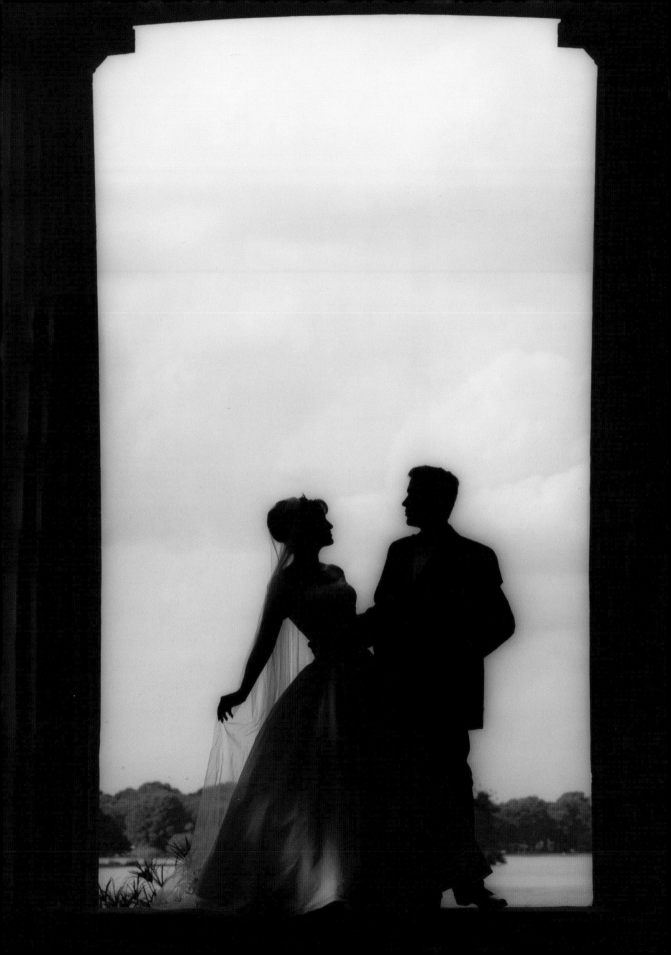

DETAILS AT THE RECEPTION

Providing professional wedding photography involves more than creating outstanding portraits of the bride and groom—it's about documenting an entire event.

In order to create a special day for their guests, the couple will have spent a great deal of time selecting just the right locations, food, flowers, table settings, centerpieces, flowers, and more. These aren't small (or inexpensive) decisions, and they need to be documented—after all, the details often define the "feel" of the event. The bride and groom will appreciate your effort to capture all the details—especially since they may be too busy on the day of the wedding

to actually enjoy how everything looked! Some examples are shown on the facing page.

These photos can also be used as a public relations device. You might be tempted to say no when the caterer asks you to make him an 8 x 10-inch print for his office. Instead—take it to the next level!

Rather than investing in one large print for the caterer (or the reception site, the florist, the decorator—anyone whose product is on display), create a print in Photoshop that shows the vendor's work and some other smaller details. Be sure to include your

logo. Now, here's the best idea: create an open area for the bride and groom to write a special note to the vendor telling them how great the event went or how beautiful everything looked (an example is shown above). With this personalized message, you can be sure that the vendor will find a place to display this image in their showroom.

To really make an impression, laminate the image and present it to the vendor in a frame. This has some serious "Wow!" value—and, trust me, you *will* be recommended!

4.

GROUP PORTRAITS

COUPLE WITH THEIR FAMILIES AND WEDDING PARTY

PLANNING

Group portraits are an important part of the photography for just about every wedding. With these images, solid planning is the key to success. Knowing when and where you'll be taking the shots—and planning the groupings—will make the process go much more smoothly.

It also helps to enlist the assistance of the maid of honor for these pictures. The bride will have a lot of things on her mind—from her appearance to the comfort of her guests. Part of the maid of honor's job is to help her and minimize her stress. As such, before you arrange the area you plan to use for group photos, you should ask the maid of honor to assist you with organizing everyone and styling the bride's gown. The maid of honor's help will be an excellent resource and help to reduce demands on the bride.

EXIT SHOTS

When I'm finishing up formals inside the church, I know that the guests and family of the bride and groom are outside, just waiting for the newlyweds to emerge from the church. Whether the guests will be throwing rice or blowing bubbles, why not get them in on things and take some fun shots of the newlyweds?

The exit is a great traditional moment, but you'll need to take control of it to get the best images. The first thing I do is get the parents, immediate family, and bridal party placed as closely as possible to the door. They will be the most enthusiastic members of the crowd, and I want their energy and emotion to surround the couple and spill over into the images. Once everything is set, I tell everyone to have fun, and start shooting!

Once you've captured a few great shots of the couple leaving the church, there are some other moments you'll want to cover during the couple's departure. I like to get a shot of the couple getting into the limousine and follow up the image with a photograph of the newlyweds inside the limo and ready to go. If they've decorated the car, you should also get a shot of the vehicle.

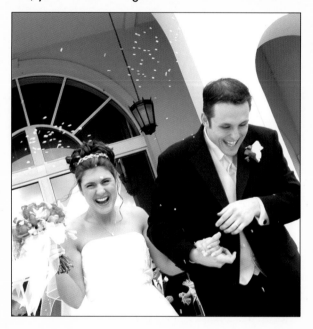

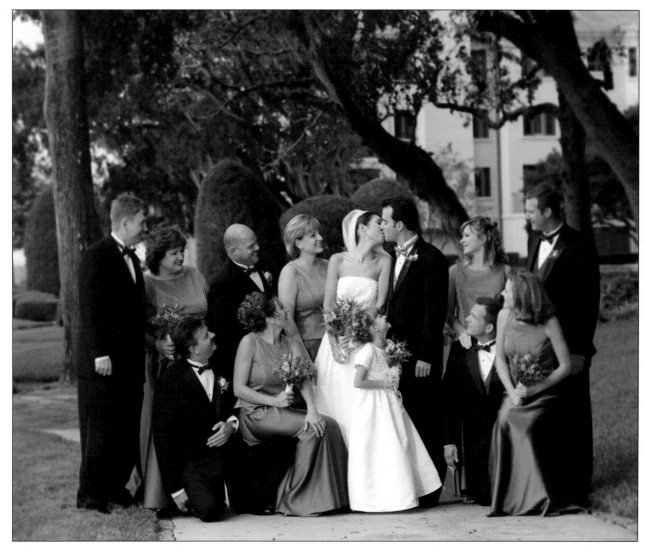

● Posing

Before diving in to photographing groups it's good to have a plan of attack. You'll be dealing with a large number of people in a great variety of groupings, so moving them in and out of the scene efficiently and with a minimum of confusion will make the shoot much more enjoyable for both you and your subjects. If you develop (and stick to) a system, you'll be surprised how quickly the shoot will move along.

Space will dictate how large the group can be and the options you have for posing—so be prepared to finesse the planned groupings to get the best results. If the church has steps leading up to the entrance, these can be employed for posing groups. Using steps allows you to place the faces of the subjects at different heights, ensuring that each face will be visible. It also helps you to create diagonal lines of faces for a more interesting composition.

● Depth of Field

As you take your group portraits, pay attention to the depth of field to ensure that the faces of the subjects are in focus from the front of the group to the back. If you have a depth-of-field-preview button, use it; if shooting digitally, review an enlarged version of the image on your LCD screen to check the

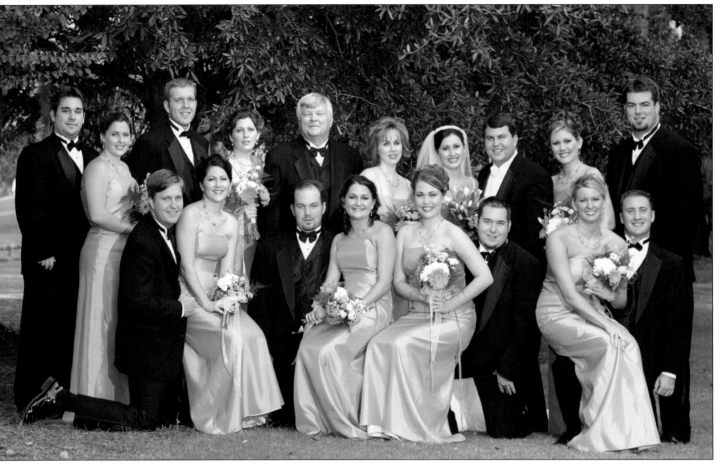

It's a good idea to carry posing stools when photographing a wedding. When posing stools are not available, however, you can seat some of the bridesmaids on the groomsmen's knees, as seen in this image.

focus. If it's not right, consider shooting from a stepladder, looking down toward the group. Because this puts the film or digital sensor plane in a position more parallel with the plane of the faces, it will help you to place the available depth of field more optimally to keep the faces sharp.

● *The Couple with the Bride's Family*

A good place to start your group photography is with the bride and groom. Once they are in position, start adding other people around them. I usually begin with the bride's family. Begin with the couple and her parents, then continue to add family members step by step: brothers and sisters, grandparents, aunts and uncles, and any other people who are special to the bride.

● *Bride with Her Family*

With the whole group posed, eliminate the groom. Now, photograph the bride alone with her whole family. The next step is to begin eliminating groups of people as you added them in the previous section. Remove the aunts and uncles, grandparents, then brothers and sisters (photographing each new grouping) until you have the bride alone with her parents. After a few shots of the bride with Mom and Dad, move on to shooting the bride alone.

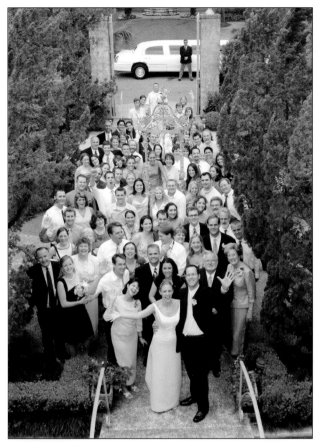

Consider shooting group images from an elevated position, like out a window or from a stepladder.

● *The Bride*

Start by shooting full-length portraits of the bride, including profiles. Then go on to do as many variations with the bride alone as you can.

● *The Couple with the Groom's Family*

Next, bring back the groom and pose the couple with the groom's family. As with the bride's family, begin by adding the parents, then the brothers and sisters, then the grandparents, then the aunts and uncles, and anyone else special to the groom.

● *The Groom with His Family*

Now, eliminate the bride and photograph the groom with his family. As before, begin eliminating family members until you have the groom alone.

● *The Groom*

I like to take the groom away to different areas of the church for his portraits, often shooting with a wide-angle lens. A stained glass window or a pew (as you see in the groom's portrait on page 60) can provide an excellent backdrop. The groom's attire is generally not as distinctive (or symbolic) as the bride's, so adding environmental elements can enhance and strengthen the image. Pay special attention to the hand posing for grooms.

● *Wedding Party Setups*

Start with the bride and groom with the best man and maid of honor. Next, begin to work with the whole group, positioning the bride and groom in the center. For one shot, pose the groomsmen on the groom's side, and the bridesmaids on the bride's side. Next, pair up couples of attendants and arrange them evenly on each side of the newlyweds. Finish by photographing the groom with his groomsmen, and the bride with her bridesmaids.

THE WEDDING PARTY

Keep in mind that the members of the wedding party don't know your organizational techniques for shooting and will need good, clear direction. You'll also need to give them time to get comfortably into position when you call them. Establishing a good, friendly rapport from the start will help create a quick but comfortable pace for shooting.

COORDINATING THE SHOOT

● *Timing*

When you are working on photographing the wedding party, time constraints will be a fact of life. The church may have another wedding or event scheduled after yours, or the group may just be eager to move on to the reception. Still, this is a very special event, and you should give yourself the time you need to capture the special images your clients will want. Here are a few helpful tips to keep in mind.

● *The Bride*

Remember that the bride is the subject to whom you should devote the most time. She is the most important person in the images, and you should position her first, styling her gown and veil with care and close attention. If possible, move the wedding party around her to avoid having to constantly restyle.

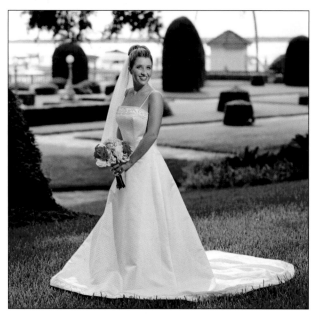

● *Working with Children*

Finally, when children are included in the wedding party, photograph them right away. Youngsters tend to get very restless when made to wait around for the grown-ups!

CUTTING THE CAKE

The cake cutting provides a nice opportunity for you to create a sequence of images for the album. I always start out by photographing the cake by itself. Often, I like to put the bridal bouquet next to it. Once I've photographed the whole cake, I also use my 180mm lens to create a close-up of the cake top alone. (After the wedding, don't forget to send a shot of the cake to the bakery. This will help them to promote their work and generate referrals for you.)

With these images done, it's time for the cake cutting. For these shots, I like to pose the bride and groom close together with their bodies turned in toward the cake (and toward each other). The couple's far arms are then placed around each other.

Together, both the bride and groom hold the cake-cutting knife in the hands closest to the camera. The first photo is taken of the couple in this pose, looking into the camera.

Next, without even changing the pose, I have the couple look down at the cake. To continue the sequence, the couple begins to cut the cake (here, you may want to move your camera and take the shot from another angle).

Once the cake is cut, I photograph the bride and groom feeding each other, and then kissing over the cake.

For the last shot in the sequence, I simply turn around and photograph the guests and their reactions to the cake cutting ceremony.

When you've shot all of these images, you should have a narrative sequence of about eight portraits that you can use in the couple's wedding album. The result is increased sales for you, and a wonderful series of storytelling images for the couple.

THE GUYS

● Before the Wedding

When I'm doing pre-wedding photography on the day of the ceremony, I always allow a little extra time for the guys to show up late. Many times they'll head out early for a game of golf or "one last drink" with the groom as a bachelor. But even if they are late, you should try to get some nice group shots so you won't have to worry about taking them after the ceremony. These are great shots for the groom's parent album.

● After the Wedding

When you're photographing the guys after the wedding, be prepared to deal with a bunch of groomsmen who just want to move on to the fun of the reception. The secret to dealing with this is to have fun with them and let them have fun on the shoot. Gain their confidence, and let them know that if they'll give you a little quality time, you'll get them on to the reception as soon as possible. With a little planning and organization, you should be able to send them on their way in about half an hour.

● Location

For the image to the right, a large window behind and to the right of the group provided nice backlighting that made this location appealing. Additionally, the furniture and fireplace make the shot look like it was taken in a living room and not in a hotel lobby.

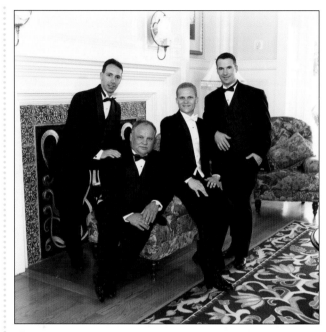

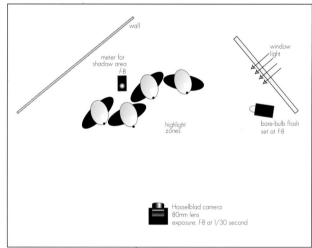

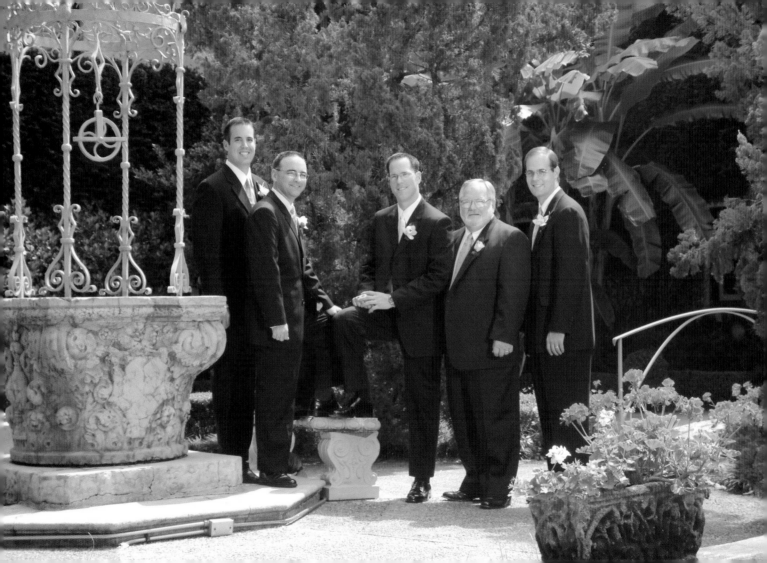

HAVING SOME FUN

● *The Rules*

There are a lot of "rules" in photography—and sometimes it's easy to get caught up in them. Yes, you need to get the traditional images the clients want, but there's no reason you can't throw out the rules for a little while and get some really fun and unique shots at the same time.

● *Be Creative*

When you're shooting a fun and energetic group of people at a wedding, be sure to have fun with them! Try out some creative ideas that will make memorable additions to their wedding album, and really reflect the character, joy, and fun of the day. Get them caught up in the action, and capture those priceless moments!

● *Add Props*

When photographing groups, sunglasses are probably the easiest prop to add—and they really add a fun look to the image. Cigars work well, too. Our clients love this look and we sell many as 8x10-inch prints.

● *Using Digital*

Remember, with digital you can do these shots at no extra cost. Most clients like the images in black & white, but we still shoot them in color; we can then digitally convert the image to present it in the way that the client prefers.

● *Learning Names*

There are a lot of people involved with weddings, but it is imperative that you learn (at the very least) the names of the bride and groom, and perhaps their moms and dads. The maid of honor and the best man can also be important resources for you (helping with getting people organized and helping the bride and groom), so it wouldn't hurt to learn their names, too.

TIPS FOR SHOOTING

During the group portrait phase of shooting, I like to take about thirty to forty frames of each family. This usually takes between thirty and forty-five minutes. By following a predetermined plan of action, this should be relatively painless. It varies from wedding to wedding based on the package the couple selects, but we generally shoot about two to three hundred images for each wedding.

When shooting the group images on film, my assistant and I usually do about three to four shots of each grouping. With digital, we now shoot only about two—since we can now easily swap heads or eyes if needed to eliminate any expression problems that might occur. We can't waste time, but it's better to be safe than sorry.

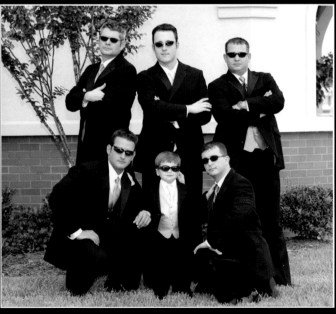

CANDID MOMENTS

With the increasing popularity of the photojournalistic style in wedding photography, candids in general have become more popular than ever. Even photographers who specialize in traditional imagery are now offering more unposed images to their clients.

● *Emotion*

What makes candids so appealing? It's the raw emotion—the ability to capture people as they really are and as they react to one of the happiest, most emotional events in their life. Unlike traditionally posed images, candids capture natural events as they unfold. (Of course, even traditional images are now often less than completely formal. Many photographers prefer to loosely pose the subjects and let nature take its course, allowing them to interact in whatever way feels natural to them.)

● *Mind Set*

When shooting truly candid images, you need to have a tremendous amount of foresight. Instead of watching what is happening at the moment, you need to concern yourself with predicting what is about to happen a few moments (or frames) in the future. Capturing natural moments also means blending into the scene—after all, people aren't as open with their emotions when they know there's a camera on them! Keep your distance and try, whenever possible, to use natural light. Selecting a high ISO setting on your digital camera, or a high film speed, will make this easier. The grain this adds can often be an asset in these images, lending a moody and artistic look—especially in black & white.

● *Digital*

Digital has helped to improve the odds of creating a successful shot since you can see your images instantly and feel free to shoot just about as many frames as you want. (Be sure to keep an extra memory card on hand, though—you don't want to find your card full when that perfect moment arises!)

● *Total Coverage*

We never do a wedding without some traditional coverage. Grandparents don't always stand gracefully, groomsmen never know what do with their hands—only some posing will make them look the way we want to remember them!

CANDIDS, NOT SNAPSHOTS

Candid images taken by a professional are not merely snapshots. Although we may not construct these images, as professionals we use all of our traditional skills to recognize when the subjects are posed in a flattering way, when the light on them is most beautiful, and when a striking composition can be created. I learned from Monte Zucker that the goal of a wedding photographer is to make the wedding look even better than it actually was. This is just as true of candid moments as posed shots.

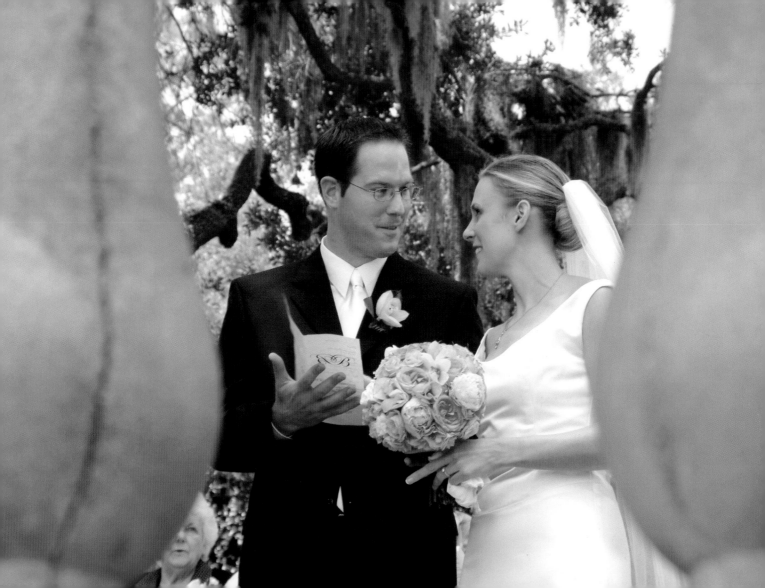

PRE-CEREMONY PORTRAITS

The most important time for me as a wedding photographer is the two hours immediately preceding the ceremony. Since most modern brides don't want to see the groom before the ceremony, this is a perfect time to create portraits of the bride and her family. It's also a good time to catch the bride with the special people we discussed during the pre-wedding consultation. This will help you free up time after the ceremony (when you will already have plenty to do!) and allow you to give the bride and her family your undivided attention.

● *The Bride's Family*

I like to start off with the bride, bridesmaids, Mom, Dad, and the bride's family. We do special shots, group shots, and images with Mom, Dad, and Mom and Dad together.

As you can see from the series of images presented here, you don't need to set up a totally different

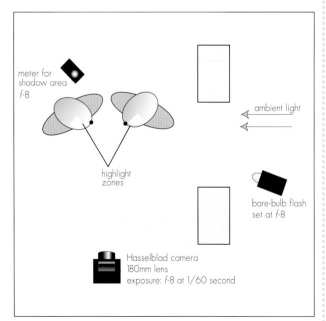

image for each grouping. Rather, choose a good location with nice light, then set up your equipment and move the groupings in and out systematically. Remember, the bride is the most important figure, so style her dress and veil carefully, then have her stay put. Then you can move the other members of the family in and out without having to restyle the bride's gown and veil.

● *Have a Plan in Place*

Since you will already have discussed with the bride the images she wants, you should be able to create an efficient plan for these groupings. Have your assis-

tant call these out for maximum efficiency. You may wish to refer to the plan for altar formals on pages 36–39 as a model. In addition, a collection of suggested shots and poses are included in the appendix on pages 116–18.

I like to come up with about twenty-four images during this phase. Keep the bride's parent album in mind as you are working. The more images of their daughter you have to offer them, the greater your sales will be.

A PERFECT WEDDING

What makes me happiest when shooting a wedding is when the event is well organized, runs on time, and allows me to produce all the images I want to get for the couple. They are investing a lot of money in my talent, and when I can get creative and pull off 200 great images, that makes any

wedding memorable. Wedding photography is something you need to put your heart into to be successful. Get involved emotionally with it, and make sure that when you leave a wedding you can say you did the very best you could—under any conditions.

5.
MARKETING AND SELLING

MASTERING THE SKILLS YOU NEED TO TURN YOUR

CREATIVE AND ARTISTIC TALENTS INTO INCOME

MARKETING YOUR STUDIO

By Deborah Lynn Ferro

Image is everything, especially when reaching for high-end clients. How our studio is decorated, how we dress, how we answer the phone, how we design our marketing pieces—all of these things project our degree of professionalism and how we do business. You only have seven seconds to make a first impression, and that first impression is long lasting!

There are all different kinds of clients out there at all different income levels. Where do you see your photography studio? We believe in going for the gold! Instead of working our way up to the client we eventually want, we believe in targeting that client first. Therefore, we tailor our promotional pieces, advertising dollars, and pricing to that market. We believe that we are selling ourselves and that our images are an extension of ourselves.

Remember that *you* make the phone ring. How? You create a plan (a direct marketing piece or a bridal show, for example), decide on a way to implement the plan, take the steps needed to put it in action, and follow up. A great way to get people to call is by getting involved in your community through the Chamber of Commerce, charities, networking with vendors, and by visiting local businesses and leaving your business cards.

• Hook

To set yourself apart, you need a hook—a style or feature that clients can only get from you. Clients

We also tell our clients that they are not only hiring a photographer but a graphic designer.

come to us for the romantic location portraits we show on the Internet and through our advertising. We also tell our clients that they are not only hiring a *photographer* but a *graphic designer*. With our ability to enhance our images using Photoshop, they are assured of a product unmatched by a mall studio.

• Samples

So, how do you get samples if you are just starting? We approached one of the venues that we wanted to photograph weddings at and offered to do a photo

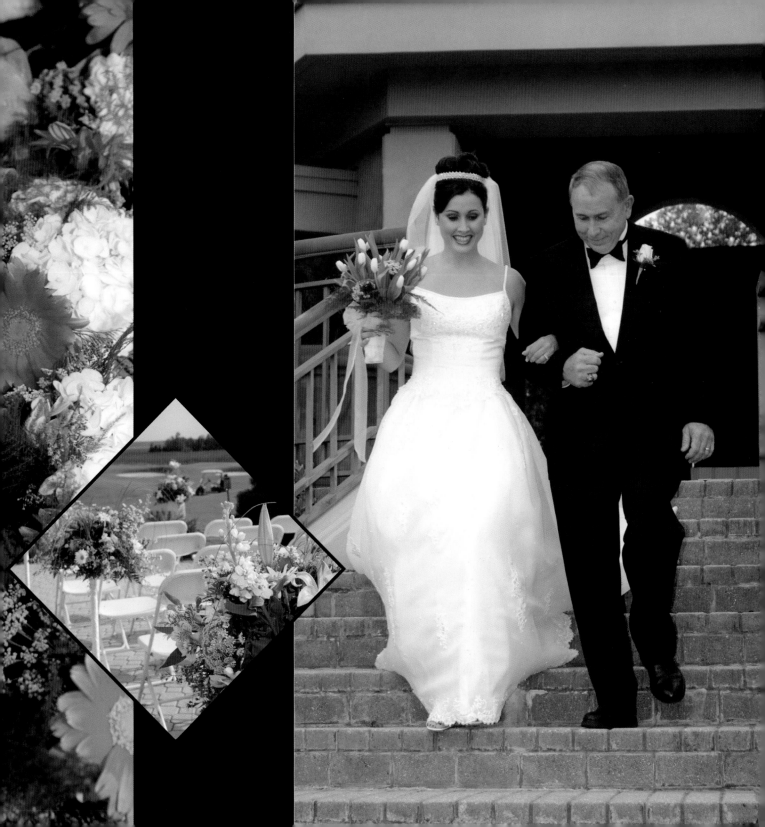

For a relaxed atmosphere with beautiful Southern Charm

Fleming Island.... the perfect wedding location!

To promote your work with local vendors, offer to do their ads!

shoot free. We involved the publisher of *Wedding and Reception Magazine*, who in turn involved other vendors who needed images. We re-created a 1920s wedding at this historical venue and had six brides, two grooms, three children, a vintage car, a horse and carriage, gowns, tuxedos, a makeup artist, and hairstylist. All the vendors were then able to use the images for their ads—as long as we were given photo credit. As a result, we had a full-page ad that we paid for as well as other ads with our name that we did not have to pay for, plus a variety of sample images for our website, studio, and marketing promotions.

We have continued to do this with other venues and because we do the shoot for free, it is a win–win situation for everyone. Because of these shoots we have developed great relationships with various vendors in the community and procured a variety of additional commercial jobs as well.

● **Wallets**

Another great marketing tool for us is to offer our wedding clients free wallet-size images created from the images shot during their engagement or bridal portrait session. We give them as many wallets as they have guests—if we can put them on the reception table at their wedding. We tell them that, in addition to being a nice gift, it is a helpful reminder for the guests to view and purchase their images online at www.Collages.net. (Collages.net has been a wonderful marketing tool as well, because we can send potential clients to view one of our weddings and develop a database of future clients from those that go online. For more on this, see pages 105–7.)

We offer our clients free wallets from their engagement session. Placing them on the reception table on the wedding gets our name in front of all of their guests.

● *Mall Promotion*

When we decided that it was time to let the community know that we do wonderful portrait work as well as wedding photography, we rented an 8 x 15-foot space in the most expensive mall in our area for a three-day show.

We set up a display of gallery images and spent three days showing our work. Because we were looking for high-end clients, we took only wall-size portraits—canvas set in beautiful frames.

The response to this mall program was overwhelming. For the cost of one bridal show, we had three days of incredible exposure to the clients in our area who are most likely to purchase our products. Because it was so successful, we are now scheduled to do this display three times per year!

Displays at a high-end shopping mall have been helpful in promoting our work.

People today are overwhelmed with junk mail and business cards. To ensure that they won't end up in the trash, put some thought and time into designing your materials.

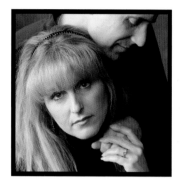
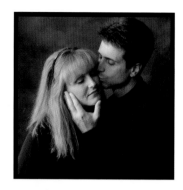
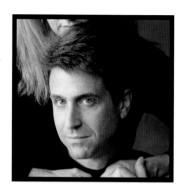

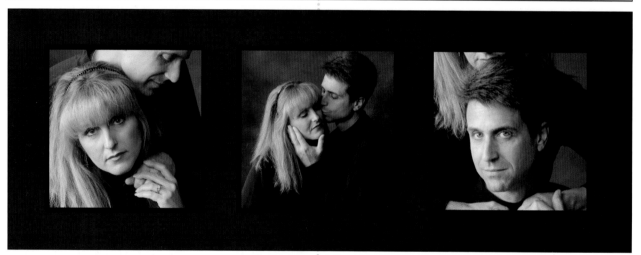

We create templates in Photoshop like the mats and frames that we sell through Albums, Inc. We are then able to suggest to our clients how to best use their images, drag and drop them to these templates, and even show them in color, black & white, and sepia. Since we have added this to our sales presentation, our portrait sales have tripled!

● *The Importance of Marketing*

Most people get into photography because they have a passion for creating images. But just being able to *create* great images doesn't pay the mortgage; *selling* great images pays the mortgage. To be successful at marketing you must have these attributes:

1. Believe in yourself (or at least act like you do!).
2. Sell yourself—it's not really your images people buy, it's you.
3. Create a plan, find a way to implement it, and take action.

4. Be consistent and don't give up. When a strategy is successful, repeat it!

Finally, remember that *you* are in control of the quality of the images you present, the demographics of your client base, and your level of success. In the end, that is your greatest asset as a marketer. After all, success doesn't just happen, *you* make it happen!

CHOOSING A WEB MASTER

By Jean Holland-Rose

When choosing a web master it is always a good idea to arrange a personal meeting—if the individual you are interested in working with is in your area. This is especially true if this individual is going to design the site, host the site, and maintain the site continuously. If he or she is not located locally, it is prudent to check references from his or her current clients. Discuss what direction your website project should take and get a price quote based on the minimum number of pages you need.

If you have a favorite site from another photography (or similar) business, provide the URL of that site for review, and ask the designer what a site such as that would cost. For a basic website, you should expect to pay about $400–500 for the overall design of the site and about $100 per page (unless you wish to include Flash animation, which is usually quoted separately). Site costs vary from designer to designer and can become much more expensive if you wish to include sophisticated elements or if your site requires additional programming or e-commerce solutions. A simple three- to four-page site is usually adequate for most small businesses.

Ask questions about the web master's preference for hosting, whether or not they provide program-

Remember, clients hire you, not your images. In addition to photos, your website should also tell them about you and why they should hire you.

ming and e-commerce solutions, and exactly how many sites they have built.

Make sure the web master hosts their sites with a reputable nationwide company rather than a home computer. In the event that problems arise with the hosting, you are better off being involved with a larger company that offers diverse services and gives

you more avenues for troubleshooting any problems that might arise.

After your site is properly programmed and designed, the site should be submitted regularly to search-engine databases for review. This ensures that clients who enter your name, location, type of business, etc., as keywords in a search engine will find a link to your site. Most hosting companies offer search-engine submission. You can also hire a company that specializes in search-engine listings (be sure to check the company's references, as there have been numerous scams reported in this industry). Alternately, you can purchase search-engine submission software and do the listing yourself. There are even free submission sites available that you can use to submit your site.

It does take time to be listed—after all, there are countless new sites being submitted every day! Patience and regular search-engine submission will, however, bring results—normally within four to six months. There are no guarantees or magic solutions for achieving good search-engine placement. For more information, however, you can research search-engine techniques readily on the web or read our book *Web Site Design for Professional Photographers* (Amherst Media, 2003).

We also welcome your inquiries. Please visit our website at www.orlandowebsitedesign.com and use our "Ask the Expert" forum to ask any questions you might have on web-site design.

PROOFING, SALES ORDERS, AND PRESENTATION

We are a totally proofless studio and sell our images exclusively through projection. The bride and groom rarely remember all of the events that take place on their wedding day. Because of this, your first presentation of their images will have a greater emotional impact when it is done in a slide-show format and set to music. For this show, you should identify the images that have most impact, and present them in the sequence they were shot on the wedding day—telling the whole story from start to finish.

● *Lightning*

After the bride and groom have viewed their wedding in our studio through projection, we also send them home with an viewable CD that expires and stops working within a selected period of time. The couple cannot copy it or print from this CD.

We create this CD using a software program called Lightning, which is available from www.fire-hand.com. The software allows us to produce a slide show with music and an album with all of the images from the wedding (with the original file names). This way, the couple can view their images in the privacy of their home and take the time to carefully make their selection for their album.

● *Studiomaster Pro*

As most wedding photographers know, most of the work comes after the wedding. For designing our albums, selling our studio portraits and engagements, as well as all of our other studio work, Fuji-film's Studiomaster Pro has been a great tool. It has reduced our production time and improved our professional presentation to the client—and it's also very user friendly.

Some of the features included in Studiomaster Pro are: digital editing, on-screen album assembly, and (our favorite) easy lab ordering. (Contact your lab to see if they are an Authorized Studiomaster Pro Lab, or visit www.studiomasterpro.com for a complete lab listing.) Another of our favorite features is "smart pages," which allow you to print multiple images on one piece of paper to fit precisely within a selected album-page template.

Fujifilm's Studiomaster Pro is available only for the Windows operating system (sorry Mac users—but once you see all of the benefits it has to offer, you just might consider buying a PC!). For the average Windows user, it normally takes only a few days

Studiomaster Pro has been a great tool for us, reducing our production time and improving our presentations.

In Studiomaster Pro, images can be rotated, organized, and retouched using menus and buttons that are easy to navigate.

to get comfortable using the program. On their website, Fujifilm offers a downloadable 15-day trial version. You can also view tutorials and check out a variety of other great features and links.

Once our images are loaded, we edit them. It is easy to maneuver throughout Studiomaster Pro using the drop-down features of the menu bar and the quick buttons of the tool bar, menus accessed via a right-click of your mouse. Images may be rotated (one at a time or in groups), and placed in any order by selecting an image and dragging and dropping it in the desired location (this can also be done with groups of images). This is great when we want to put our images into a chronological order to show the whole story of the wedding day. We can also retouch, clone, burn and dodge, eliminate red-eye, and choose from an extensive palette of colors for other effects (like borders and backgrounds).

An important feature is the ability to hide rejected images from the client's view. After editing, we simply export the images to Collages.net (see page 105) for viewing and ordering.

Creating an album has never been easier. Not only is the on-screen assembly effortless, but the end result leaves you seeing dollar signs. We also love how easy it is to produce a slide show! You can show your customer a slide show of the entire order including the print order and also the album order. The slide show enables us to choose transitions and

COLOR CORRECTION

When it comes to achieving consistent color in your digital images, the best advice I can give you is to calibrate your monitor to your lab. The whole idea of using this ordering software is to save you time and money—and if you consistently need to do reprints because of color problems, you won't see these rewards. Even if you know you can nail the color on every image, we recommend photographers evaluate their time spent doing these color adjustments and compare it to the cost of having a professional lab handle this task. You may be surprised at the results.

With Studiomaster Pro, creating albums has never been easier!

display times—we can even add music and our own custom transitions. Best of all, it can be exported to a folder or burned to a CD.

Finally, viewing the Job Summary before sending the job to print gives us a chance to review the order and an opportunity to increase our sales by easily adding to the quantities. You can also archive your jobs once you feel you're finished with them.

To sum it up, Fujifilm's Studiomaster Pro is extremely user friendly. With so many products out

there, I think we can get overwhelmed very easily. Fujifilm's Studiomaster Pro is an invaluable tool for our studio and our business.

● *Collages.net*

A few years ago, Clay Blackmore introduced us to a new company called Collages.net, which has built its business on helping photographers market their studios. We were hesitant at first, but it didn't take long to realize that posting images online was very well received by our customers.

So what exactly is Collages.net? Collages.net is a web-based system that allows us to post images from our events onto a password-protected, fully functional, e-commerce website. They also create a custom CD slide show set to music, which we give to the bride and groom as a permanent keepsake of their wedding day.

Collages.net deals with both film and digital images. The company scans the paper proofs from the images that I shoot on film and uploads them to the website. The images that Deborah shoots with the digital camera can either be burned to a CD-R and sent with the proofs or uploaded to Collages.net using their simple FTP system.

Before the Event. Before we shoot an event, we show our clients one of our favorite CD slide shows. This has a very emotional impact—as they watch it, we know our customers are imagining this as their wedding day. It doesn't take long before the bride-to-be or the mother gets teary eyed and tells us that they want the same thing for their event!

Then we explain the benefit of having a personal website where their family and friends can enjoy the images as well. How often do guests at a wedding get to see the pictures from that day? Hardly ever! That is why we offer this website to our clients.

The event kit includes cards for recording the guest's e-mail addresses so they can be notified when the couple's web site is ready to be viewed.

These products set us apart from other studios and are a great way to show off our work. Of course, we also benefit because the family and friends can order their favorite images directly from the website. They also become our potential customers. They see our work, they like it, and they call us next time they need a professional photographer. The referrals alone are increasing our revenue with every event we post!

During the Event. Collages.net gives us an event kit that includes small cards to place at each table with a nice pen so guests can write down their e-mail addresses. There is also a large e-mail address collection card that is perfect for placing next to the guest book. Also included is an announcement to give the DJ or band leader so they can tell the guests that the wedding images are going to be online and that everyone should put their e-mail address on the card to be notified when the website is ready. This lets us concentrate on capturing each critical moment throughout the day!

After the Event. Once we've received all of our images from the lab and have adjusted the digital images the way we want them, we place the images in the order we want them to appear on the CD slide show, put them into the prepaid FedEx shipping box that Collages.net provides, and we send them out. We also include the e-mail addresses that we collected at the reception. Collages.net then scans, categorizes, uploads the website, and builds the CD slide show within two business days of receiving our job! They can build two sites for every wedding or event that we shoot; one for all the event guests to enjoy and one for us and our clients called the "Client

RECEPTION IMAGES

I know that a lot of photographers hate doing table shots and hate the idea of hauling a portable backdrop to a wedding. I must admit—it can be annoying. Of course, you may change your mind when you find an e-mail order for $1100! With Collages.net, we make all of the guests part of the photography. They can't wait to see the photos and love being able to order the images from home and at their convenience. We find it a great way to add to our income!

Proofing Area." This lets customers log into their own proofing site either in the studio or at home, make their selections, and place orders. When the site is done, the guests are immediately notified via Collages.net's e-mail notification program with a message that provides a direct link to our studio web site along with the passwords to access the custom site.

Additional Features. When guests log into our event sites, they type their e-mail address. The system records these and builds a database of all the visitors to our sites. We then use the e-mail marketing tool to create special messages from the studio. We can choose to send them to every person who has ever logged into one of our sites, to just the direct customers, or to guests from a specific event. This is a perfect way of tactfully marketing to every friend or family member who attends one of our online events!

With Collages.net, you can either fulfill orders yourself or through a participating lab. If you choose to fulfill the image manually, simply follow your current method of fulfillment. If you want to use one of the participating labs, go to MyLabPartner.net and choose from the list of participating labs. Depending

An event site page on Collages.net.

on the services and products available, you will be able to place your order online just as you would if you were filling out an order bag and mailing it in to the lab! When you submit the order, the MyLab-Partner.net tool will find the original image on your hard drive or as a saved scan of the negative on the lab's server and send the image directly to the lab to be printed. No more pulling negatives!

Collages.net has had a huge impact on our business. If you have any questions about Collages.net, or would like a current list of participating MyLabPartner labs, call Collages.net at (877)NET-PHOTO.

STUDIO DESIGN

As you've seen throughout this section on marketing, taking great pictures is just part of the business of wedding photography. It's also important to have a great image—to have people perceive your studio as a great business to work with. The design of your studio goes a long way toward solidifying the impression that your studio is a professional, friendly, and high-quality organization.

● *Consultation Rooms*

When people enter your reception and consultation areas, they should feel comfortable. Nice lighting and inviting furniture are important, and you may also choose to have soft music playing, beverages available, and any other amenities you feel your clients will appreciate. To the right, you can see two images from inside our studio. Notice that the colors are warm and inviting. Although the area is a showroom, it also includes areas to sit and talk.

Showcase your best images and display them in beautiful frames—and don't forget to make a big impression with some large prints. Once a client sees the impact these have, they'll be more inclined to order large prints of their own images.

Whatever the decor you choose, make sure it looks neat and up to date. Several nice examples of studio interiors are shown on the next two pages.

● *Exterior*

Whether your studio is located in a commercial or residential setting, creating an inviting exterior is also

Interior images from Signature Studios, Inc.

Interior images from the Munoz studio. Photographs by Tomas Munoz.

Interior images from the studio of Martin Schembri. Photograph by Martin Schembri.

Interior images from the studio of Bruce Wilson. Photograph by Bruce Wilson.

Exterior images from Signature Studios, Inc.

great for engagement and bridal portraits—and having lovely settings right outside your door cuts down on travel time.

Camera Rooms. One of the biggest challenges when designing a camera room is to develop a plan for lighting. You'll need to ask yourself several questions. Do you plan to photograph both individuals *and* groups? Do you want to use large room-size sets or simpler backdrops and smaller set elements? What lighting style do you want to use—hard light, soft light, single light sources and reflectors, multiple light sources, or natural window lighting? Some of the answers to these questions will depend on the amount of space you have to work with.

In general, portrait lighting setups require the use of one to five light sources to illuminate the subject(s) in a flattering way. To design a studio with truly versatile lighting, you will need to consider both your current clients and the styles they prefer as well as those clients you want to have in the future (say, if you do mostly headshots now but plan to start doing more family portraits in a couple of years).

Let's start with five light sources. Starting from the back of the studio, you will have: a background light, a hair light, a main light, a key light, and a fill

important. The building and parking areas should be in good repair, and the lawn should be trimmed. Any plants or flowers should be well maintained.

● *Shooting Areas*

Like all of the other areas of the studio that your clients see, shooting areas need to be clean and well organized. More than any other area, though, these spaces need to be functional. The better designed the setup is, the more efficiently you'll be able to work in it.

Outdoor Shooting Areas. If your studio has outdoor space around it, consider designing some versatile outdoor shooting areas. Outdoor images are

The camera room at Signature Studios, Inc.

Folding light stands (left) are great for traveling, but require a lot of floor space in the studio and are hard to stabilize. Steel stands with caster bases (right) are stable and move with ease, making them a good choice for use in a studio environment.

light. What is the best way to position these lights in your studio? The answer is light stands—but there are several types to choose from.

You can use folding light stands. These stands are great for traveling because they are light and pack up easily—but even with wheels they take up a lot of floor space.

Another alternative is a heavy caster-based steel stand with an air cushioned upright. Photogenic makes this stand with either a 19- or 25-inch diameter base and up to an 8-foot tall telescoping upright. This style of stand is good in a studio environment because it is very stable and rolls around with ease.

Because of its weight and non-folding design, it's not suited for location work.

We decided that the best way to support our lights was to use a Photogenic Master Rail system. This is a system of fixed rails attached to the ceiling and moving rails (with scissored lifts) to raise and lower your lights. In the right studio, this system will let you move any light to any position. The scissored lift lets the light revolve 360 degrees and tilt from about 45 degrees up to straight down. The biggest plus to this system is there are no stands on the floor.

Like all light supports, the Master Rail also has its limitations. The ceiling height is the biggest de-

termining factor, since your lights can only be raised to about 33 inches below ceiling height. A good ceiling height for the Master Rail is at least 12 feet and no more than 14 feet. A 12-foot ceiling height will get your flash tube a little over 9 feet off the floor (large modifiers, like soft boxes, may extend closer to the floor and ceiling).

The Master Rail can be attached to most any ceiling type, as long as it is level (otherwise, the lights will roll down to the lowest point of the system)—although you can compensate for this by using spacers between the rails and the ceiling. Other things to consider are the length and width of the studio, which walls you want to photograph in front of, room lighting that could obstruct the rail layout, where the outlets are located and of course what strobe systems you want to use.

When designing a Master Rail system, you'll need to figure out where you want to photograph your subject. You may have only one wall to hang your background system on, or there may be a window that you want to use for fill or hair light. Next, you need to plan how close the lights need to be. Does the hair light need to be able to go behind the subject? Now how far to the side do you want the lights to go? Do you want them to go all the way to the walls? Do they need to stop short to clear a light fixture or an air conditioner duct?

Installing a Master Rail system is a lot like building a giant erector set. Once you've figured out where you want your lights to be, you lay out the rails on the floor so they will allow the lights to move where you want them. After laying out the rails, simply attach the fixed rails to the ceiling, sliding on the traverse rails, attaching the light lifts, hanging the lights, and plugging in the power cords.

After the rail system has been installed, check the movement of all the lights. Look for freedom of movement from front to back and up and down, as well as any clearance problems you may have with the light modifiers you are using.

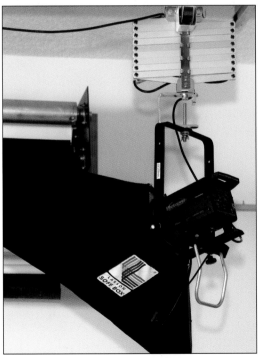

The Master Rail system from Photogenic offers a convenient way to position lights in your studio.

APPENDIX

SUCCESSFUL WEDDING PHOTOGRAPHY

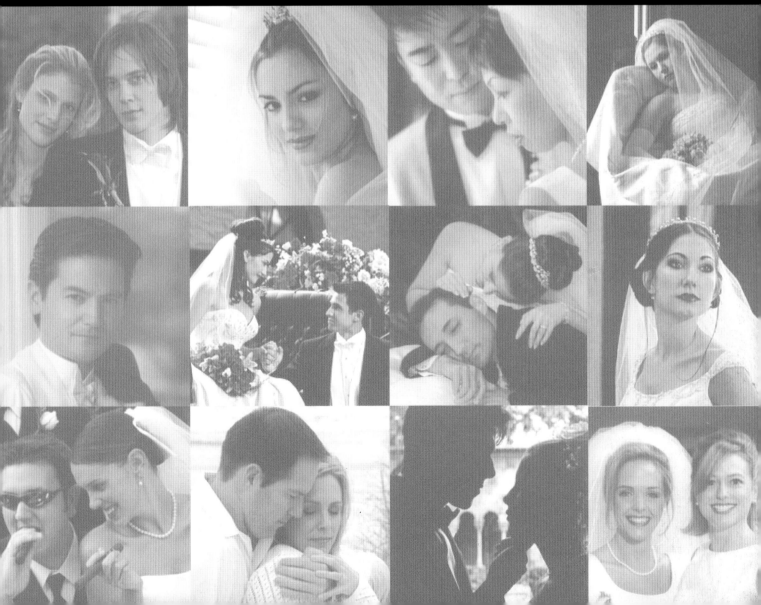

SUGGESTED POSES AND GROUPINGS

With all the activity and people at a wedding, it can be easy to miss a shot that the couple considers important. The following are some of the common poses and groupings. Discuss these before the wedding with the couple to see what they want and how to tailor your photography to their needs (for example, if the bride's parents are divorced does she want them together in the photos or will it be easier to do separate shots of her with each one?). Once you know what the couple expects, you will be better prepared to deliver it on the wedding day!

Bride (before the wedding)
1. Bride full length
2. Bride full-length profile
3. Bride ¾ length
4. Bride ¾-length profile
5. Bride, head and shoulders
6. Bride, head and shoulders (profile with flowers)
7. Bride looking into mirror
8. Bride fixing her lipstick or blush

Bride with Attendants
9. Bride with each girl (full length)
10. Bride with each girl (¾ length with flowers)
11. Bride with each girl (looking at each other)
12. Bride with all bridesmaids in grouping
13. Bride sitting with bridesmaids around her

Bride with Mom
14. Bride with Mom (full length)
15. Bride with Mom (¾ length)

16. Bride with Mom (looking at each other)
17. Bride and Mom fixing veil
18. Bride giving Mom a kiss

Bride with Dad
19. Bride with Dad (full length)
20. Bride with Dad (¾ length)
21. Bride with Dad (looking at each other)
22. Bride fixing Dad's tie (turned in profile toward each other)
23. Bride giving Dad a kiss (Dad looks at camera)

Bride with Family
24. Bride with Mom and sisters
25. Bride with Mom, sisters, and grandmother
26. Bride with Dad and brothers
27. Bride with Dad, brothers, and grandfather
28. Bride with Mom and Dad
29. Bride with Mom, Dad, brothers, and sisters
30. Bride with Mom, Dad, brothers, sisters, and Grandparents
31. Bride with grandparents

Groom (before the wedding)
32. Groom (full length)
33. Groom (¾ length)
34. Groom profile
35. Groom in front of mirror fixing his tie

Groom with Groomsmen
36. Groom with each groomsman (¾ length)
37. Groom with each groomsman (full length)
38. Groom with entire party of groomsmen

Groom and Mom

39. Groom and Mom (full length)
40. Groom and Mom (¾ length)
41. Groom with Mom fixing his boutonniere (profile)
42. Groom with Mom placing a kiss on his cheek
43. Groom with Mom (looking at each other)
44. Groom placing kiss on Mom's cheek

Groom and Dad

45. Groom and Dad (full length)
46. Groom and Dad (¾ length)
47. Groom shaking hands with Dad (profile)
48. Groom shaking hands with Dad (looking into camera)
49. Groom fixing Dad's tie (profile)

Groom with Family

50. Groom with Mom and sisters
51. Groom with Mom, sisters, and grandmother
52. Groom with Dad and brothers
53. Groom with Dad, brothers, and grandfather
54. Groom with Mom and Dad
55. Groom with Mom, Dad, brothers, and sisters
56. Groom with Mom, Dad, brothers, sisters, and Grandparents
57. Groom with brothers and sisters
58. Groom with brothers
59. Groom with sisters
60. Groom with grandparents

Ceremony

61. Parents coming down the aisle
62. Parents lighting candles
63. Each bridesmaid and groomsman
64. Flower girl
65. Ring bearer
66. Bride and Dad before they walk down the aisle
67. Bride coming down the aisle

68. Bride kissing dad on altar
69. For Jewish weddings, Mom and Dad kissing bride before giving her away
70. Full-length images from the back of the church
71. Images from partway down the aisle
72. Bride and groom lighting candles
73. Bride and groom kneeling, usually facing each other
74. Bride and groom kissing
75. Bride and groom returning down the aisle

Return to the Altar (after the ceremony)

76. Bride and groom on either side of minister (full length)
77. Bride and groom on either side of minister (¾ length)
78. Bride placing ring on groom
79. Groom placing ring on bride
80. Bride and groom kissing

Bride (after the wedding)

81. Bride with her parents, brothers, sisters, grandparents, and anyone else who is special to her
82. Bride with her parents, brothers, sisters, and grandparents
83. Bride with her parents, brothers and sisters
84. Bride with her parents
85. Bride alone

Groom (after the wedding)

86. Groom with his parents, brothers, sisters, grandparents, and anyone else special to him
87. Groom with his parents, brothers, sisters, and grandparents
88. Groom with his parents, brothers, and sisters
89. Groom with his parents
90. Groom alone

Bride and Groom

91. Full-length photos of bride and groom
92. ¾-length photos of bride and groom
93. Bride and groom with bride's parents
94. Bride and groom with bride's parents, brothers, and sisters
95. Bride and groom with bride's parents, brothers, sisters, and grandparents
96. Bride and groom with bride's parents, brothers, sisters, grandparents, and anyone else special to the bride
97. Bride and groom with groom's parents
98. Bride and groom with groom's parents, brothers, and sisters
99. Bride and groom with groom's parents, brothers, sisters, and grandparents
100. Bride and groom with groom's parents, brothers, sisters, grandparents, and anyone else special to the groom

Bridal Party

101. Bride with maid of honor
102. Groom with best man
103. Bride and groom in center with groomsmen on his side and bridesmaids on hers
104. Bride and groom in center with attendants paired up around them
105. Groom with groomsmen
106. Bride with bridesmaids

Exit Shots

107. Leaving the church
108. Bride and groom entering the limousine
109. Bride and groom in the limousine

Reception Photos

110. Dining area
111. Table setup with flowers
112. Wedding cake
113. Wedding party as they arrive
114. First dance
115. Best man making toast
116. Best man between newlyweds after toast
117. Blessing or cutting of the bread
118. Champagne toasts between members of the bridal party
119. Parents and family members toasting
120. Table shots (leave three or four people sitting, then bring the rest of those at the table around behind them)
121. Candids of the guests and events
122. Candids of bride and groom mingling and greeting guests
123. Dance shots
124. Bride dancing with Dad
125. Groom dancing with Mom
126. Bride and groom with grandparents
127. Parents
128. Grandparents
129. Bridal party couples
130. The cake cutting
131. Bride and groom feeding each other
132. Bride and groom "cake kissing"
133. Bride taking off garter
134. Groom about to toss garter
135. Bachelors trying to catch the garter
136. Bride tossing bouquet
137. Women trying to catch the bouquet
138. Good-bye shot

SAMPLE COPYRIGHT AND MODEL RELEASE FORM

YOUR LOGO

Copyright Law

Federal copyright laws preserve the right to exclusive use of negatives, digital files captured, and reproductions for _____. In exchange for a model release of the images taken, _____ will give each participant a CD of JPG files of requested images from that day for their own use. If they wish to have any image retouched and printed at our studio, it will be at our regular portrait print prices.

_____ uses various images they capture for their portfolio, samples, self-promotions, entry in photographic contests and art exhibitions, editorial use, display inside or outside the studio, in published magazines and books distributed nationally, and on their websites.

Model Release

I, _____, hereby give _____ my written permission to use any of the photographs taken of me on _____ for their own purposes as stated in the previous paragraph.

Signature: _____ Date: _____

Witnessed by: _____ Date: _____

If you are under the age of eighteen, please have a parent or legal guardian sign also:

Parent/Guardian: _____ Date: _____

YOUR STUDIO • 555 MAIN STREET • ANYTOWN, FL 55555 • (555)555-5555

SAMPLE WEDDING CONTRACT

AGREEMENT FOR WEDDING AND EVENT PHOTOGRAPHY

YOUR STUDIO, INC. AGREES TO PHOTOGRAPH THE WEDDING/EVENT OF:

_____ & _____

ON: _____ CONTRACTED TIME TO START: _____

DESCRIPTION OF PHOTOGRAPHIC SERVICES TO BE PROVIDED:

Professional fee includes unlimited coverage and unlimited images on the day of the event, custom album design, album production, consultations, formal bridal portrait with one photograph for press release, bridal registry service, and membership in our lifetime portrait program.

ALL ALBUMS AND PRODUCTS ARE PURCHASED A LA CARTE FROM PROFESSIONAL FEE

Bride/Client's Name:_____

Address:_____

City: _____ State: _____ Zip:_____

Phone: (Hm) _____ (Wk) _____ (Cell) _____ (Fax) _____

Ceremony Location: _____

Reception/Event Location: _____

Professional Fee	$_____	
Plus Sales Tax of 8.0%	$_____	
Total Due	$_____	
Less Retainer	$_____	Date Paid:_____
(50% min. of Professional Fee)		

Due two weeks before event: balance of professional fee + 80% of selected products (minimum product purchase must be one wedding album selected from Your Studio, Inc. price)

$_____ Date Due:_____

Terms and conditions of this contract with Your Studio, Inc. are understood. The terms of this agreement

(dated) _____, 20___, are accepted by: _____ and _____.

CONTRACTING PARTY STUDIO REPRESENTATIVE

TERMS AND CONDITIONS—PLEASE READ CAREFULLY

1. Dates are reserved only with a deposit of 50% of the professional fee, which includes a nonrefundable retainer of $_____, paid by cash, check, or credit card. The retainer will apply toward the contracted service. All cancellations must be made in writing by the contracting party. In the event of cancellation, any deposits paid over and above the nonrefundable retainer will be returned, less liquidated charges for services rendered up to that date.

2. At any event requiring services of the photographers/assistants for over five hours, meal(s) will be provided by the contracting party.

3. Missed payments may result in forfeiting the contracted date. After the event, the balance of any products purchased will be due in full no later than two weeks after the viewing appointment. No part of any order will be delivered until full payment is made.

4. Once a service is chosen or an order is placed and all necessary payments made, the sale is final and nonrefundable. No verbal changes will be accepted. Any schedule or order changes must be documented, submitted, and signed by both the

contracting party/parties and the studio for confirmation and mutual authorization.

5. The above signed will be notified upon completion of the previews and of the final order. Upon notification, the above signed must arrange for viewing within a reasonable time period, not to exceed thirty (30) days. The studio is not responsible for any damage that may be incurred while the previews or the final order is in storage after the thirty (30) day period.

6. The above signed acknowledge that they have received, read, and understand Your Studio, Inc.'s current price list, which is incorporated herein by reference. Product price is guaranteed once deposit is made. All additional add-ons, reprints, etc. will be subject to current price at time of order. All prices are guaranteed up to sixty (60) days after viewing of images.

7. All special request photographs (e.g., special groupings, table shots at the reception, etc.) must be purchased. Any negative that has a minimum of one (1) print ordered will be retained for one (1) year. All other originals and their negatives will be discarded.

8. Images will be available for viewing at the studio approximately 5 to 8 weeks after the event date. All event orders must be placed no later than 2 weeks after the viewing appointment. Any orders in addition to albums must be prepaid. Upon receipt of payment in full, 100 images approved by the contracting party will be placed on our website at www.your studioinc.com for viewing. Delivery of Your Studio, Inc.'s hand assembled album(s) is ordinarily within 9 to 12 weeks after the receipt of the order. This time may vary based upon the size and style of the album(s).

9. Federal Copyright Laws preserve the right to exclusive use of negatives, digital files, and reproductions for Your Studio, Inc. The Studio shall only make reproductions for the Client, the Client's family, friends, or acquaintances, or for the Photographer(s) portfolio, samples, self-promotions, entry in photographic contest or art exhibitions, editorial use, or for display within or on the outside of the Studio. If the Studio desires to make other uses, the Studio shall not do so without first obtaining the written permission of the Client. *All photographs are copyrighted. It is illegal to reproduce professional photographs.*

10. Your Studio, Inc. shall be the *exclusive* photographer retained by the Client for the purpose of photographing the wedding or event. Due to the limited time restriction of the event, family and friends of the Client shall be permitted to photograph the wedding/event as long as they shall not interfere with the Photographer's duties and do not photograph poses arranged by the Photographer.

11. Your Studio, Inc. cannot be held responsible for lack of coverage resulting from weather conditions or schedule complications caused by, but not limited to, anyone in or at the event, or by the church/synagogue restrictions. Due to the fact that weddings/mitzvahs are uncontrolled events, we cannot guarantee any specific photograph or pose. We will, however, attempt to honor special requests. Due to the limited and subjective nature of the event, Your Studio, Inc. cannot predict or guarantee the final photographic results. Your Studio, Inc. may substitute another photographer to take the photographs in the event of illness or inability to perform. In case of such substitution, Your Studio, Inc. warrants that the photographer taking the photographs shall be a competent professional.

12. If Your Studio, Inc. cannot perform this Agreement due to a fire or other casualty, act of God, failure of transportation or equipment or other cause beyond the control of the parties, or due to photographer's illness, the Studio shall return deposits made by the Client but shall have no further liability with respect to the agreement. This limitation on liability shall also apply in the event the photographic materials are damaged in processing, lost in shipping, or otherwise lost or damaged without fault on the part of the Studio. In the event the Photographer fails to perform for any other reason, the Studio shall not be liable for any amount in excess of the retail value of the Client's order.

13. Your Studio, Inc. takes utmost care with respect to the exposure, development, storage and delivery of photographs. If Your Studio, Inc. cannot comply with the terms of this contract, its liability is limited to a refund of monies paid.

14. The contracting party agrees to pay all legal fees, attorney's fees, and costs that may be incurred in the process of collection of any or all of the unpaid balance owed to Your Studio, Inc. Venue of all legal action shall take place in (*photographer's county and state*).

15. If a Court of proper jurisdiction rules that one or more provisions of this agreement are invalid, the remainder of this agreement shall remain in force.

16. Your Studio, Inc. is not liable for any damage to original negatives or digital files beginning one (1) year following the event date.

INDEX

WEDDING PHOTOGRAPHY WITH ADOBE® PHOTOSHOP®

Rick Ferro and Deborah Lynn Ferro

Get the skills you need to make your images look their best, add artistic effects, and boost your wedding photography sales with savvy marketing ideas. $34.95 list, 8.5x11, 128p, 100 color images, index, order no. 1753.

ARTISTIC TECHNIQUES WITH ADOBE® PHOTOSHOP® AND COREL® PAINTER®

Deborah Lynn Ferro

Flex your creativity and learn how to transform photographs into fine-art masterpieces. Step-by-step techniques make it easy! $34.95 list, 8.5x11, 128p, 200 color images, index, order no. 1806.

PORTRAIT PHOTOGRAPHER'S HANDBOOK, 3rd Ed.

Bill Hurter

A step-by-step guide that easily leads the reader through all phases of portrait photography. This book will be an asset to experienced photographers and beginners alike. $34.95 list, 8.5x11, 128p, 175 color photos, order no. 1844.

GROUP PORTRAIT PHOTOGRAPHY HANDBOOK

2nd Ed.

Bill Hurter

Featuring over 100 images by top photographers, this book offers practical techniques for composing, lighting, and posing group portraits—whether in the studio or on location. $34.95 list, 8.5x11, 128p, 120 color photos, order no. 1740.

THE BEST OF WEDDING PHOTOGRAPHY, 3rd Ed.

Bill Hurter

Learn how the top wedding photographers in the industry transform special moments into lasting romantic treasures with the posing, lighting, album design, and customer service pointers found in this book. $34.95 list, 8.5x11, 128p, 200 color photos, order no. 1837.

PHOTOGRAPHING CHILDREN WITH SPECIAL NEEDS

Karen Dórame

This book explains the symptoms of spina bifida, autism, cerebral palsy, and more, teaching photographers how to safely and effectively work with clients to capture the unique personalities of these children. $29.95 list, 8.5x11, 128p, 100 color photos, order no. 1749.

PROFESSIONAL PHOTOGRAPHER'S GUIDE TO SUCCESS IN PRINT COMPETITION

Patrick Rice

Learn from PPA and WPPI judges how you can improve your print presentations and increase your scores. $29.95 list, 8.5x11, 128p, 100 color photos, index, order no. 1754.

PHOTOGRAPHER'S GUIDE TO WEDDING ALBUM DESIGN AND SALES

Bob Coates

Enhance your income and creativity with these techniques from top wedding photographers. $29.95 list, 8.5x11, 128p, 150 color photos, index, order no. 1757.

THE BEST OF PORTRAIT PHOTOGRAPHY

Bill Hurter

View outstanding images from top professionals and learn how they create their masterful images. Includes techniques for classic and contemporary portraits. $29.95 list, 8.5x11, 128p, 200 color photos, index, order no. 1760.

THE ART AND TECHNIQUES OF BUSINESS PORTRAIT PHOTOGRAPHY

Andre Amyot

Learn the business and creative skills photographers need to compete successfully in this challenging field. $29.95 list, 8.5x11, 128p, 100

THE BEST OF
TEEN AND SENIOR
PORTRAIT PHOTOGRAPHY

Bill Hurter

Learn how top professionals create stunning images that capture the personality of their teen and senior subjects. $34.95 list, 8.5x11, 128p, 150 color photos, index, order no. 1766.

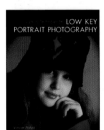

LIGHTING TECHNIQUES FOR
LOW KEY PORTRAIT
PHOTOGRAPHY

Norman Phillips

Learn to create the dark tones and dramatic lighting that typify this classic portrait style. $29.95 list, 8.5x11, 128p, 100 color photos, index, order no. 1773.

THE BEST OF WEDDING
PHOTOJOURNALISM

Bill Hurter

Learn how top professionals capture these fleeting moments of laughter, tears, and romance. Features images from over twenty renowned wedding photographers. $34.95 list, 8.5x11, 128p, 150 color photos, index, order no. 1774.

THE DIGITAL DARKROOM
GUIDE WITH ADOBE®
PHOTOSHOP®

Maurice Hamilton

Bring the skills and control of the photographic darkroom to your desktop with this complete manual. $29.95 list, 8.5x11, 128p, 140 color images, index, order no. 1775.

COLOR CORRECTION AND
ENHANCEMENT WITH
ADOBE® PHOTOSHOP®

Michelle Perkins

Master precision color correction and artistic color enhancement techniques for scanned and digital photos. $29.95 list, 8.5x11, 128p, 300 color images, index, order no. 1776.

BEGINNER'S GUIDE TO
PHOTOGRAPHIC LIGHTING

Don Marr

Create high-impact photographs of any subject with Marr's simple techniques. From edgy and dynamic to subdued and natural, this book will show you how to get the myriad effects you're after. $29.95 list, 8.5x11, 128p, 150 color photos, index, order no. 1785.

POSING FOR PORTRAIT
PHOTOGRAPHY
A HEAD-TO-TOE GUIDE

Jeff Smith

Author Jeff Smith teaches surefire techniques for fine-tuning every aspect of the pose for the most flattering results. $34.95 list, 8.5x11, 128p, 150 color photos, index, order no. 1786.

PROFESSIONAL
MODEL PORTFOLIOS
A STEP-BY-STEP GUIDE FOR
PHOTOGRAPHERS

Billy Pegram

Learn to create portfolios that will get your clients noticed—and hired! $34.95 list, 8.5x11, 128p, 100 color images, index, order no. 1789.

THE PORTRAIT PHOTOGRAPHER'S
GUIDE TO POSING

Bill Hurter

Posing can make or break an image. Now you can get the posing tips and techniques that have propelled the finest portrait photographers in the industry to the top. $34.95 list, 8.5x11, 128p, 200 color photos, index, order no. 1779.

MASTER LIGHTING GUIDE
FOR PORTRAIT PHOTOGRAPHERS

Christopher Grey

Efficiently light executive and model portraits, high and low key images, and more. Master traditional lighting styles and use creative modifications that will maximize your results. $29.95 list, 8.5x11, 128p, 300 color photos, index, order no. 1778.

DIGITAL INFRARED
PHOTOGRAPHY

Patrick Rice

The look of infrared photography has long made it popular—but with digital it's easy too! Add digital IR to your repertoire with this comprehensive book. $29.95 list, 8.5x11, 128p, 100 b&w and color photos, index, order no. 1792.

LIGHTING TECHNIQUES FOR
FASHION AND GLAMOUR
PHOTOGRAPHY

Stephen A. Dantzig, PsyD.

In fashion and glamour photography, light is the key to producing images with impact. With these techniques, you'll be primed for success! $29.95 list, 8.5x11, 128p, over 200 color images, index, order no. 1795.

WEDDING AND PORTRAIT PHOTOGRAPHERS' LEGAL HANDBOOK

N. Phillips and C. Nudo, Esq.

Don't leave yourself exposed! Sample forms and practical discussions help you protect yourself and your business. $29.95 list, 8.5x11, 128p, 25 sample forms, index, order no. 1796.

THE BEST OF PHOTOGRAPHIC LIGHTING

Bill Hurter

Top professionals reveal the secrets behind their successful strategies for studio, location, and outdoor lighting. Packed with tips for portraits, still lifes, and more. $34.95 list, 8.5x11, 128p, 150 color photos, index, order no. 1808.

MARKETING & SELLING TECHNIQUES
FOR DIGITAL PORTRAIT PHOTOGRAPHY

Kathleen Hawkins

Great portraits aren't enough to ensure the success of your business! Learn how to attract clients and boost your sales. $34.95 list, 8.5x11, 128p, 150 color photos, index, order no. 1804.

MASTER GUIDE FOR UNDERWATER DIGITAL PHOTOGRAPHY

Jack and Sue Drafahl

Make the most of digital! Jack and Sue Drafahl take you from equipment selection to underwater shooting techniques. $34.95 list, 8.5x11, 128p, 250 color images, index, order no. 1807.

DIGITAL PHOTOGRAPHY BOOT CAMP

Kevin Kubota

Kevin Kubota's popular workshop is now a book! A down-and-dirty, step-by-step course in building a professional photography workflow and creating digital images that sell! $34.95 list, 8.5x11, 128p, 250 color images, index, order no. 1809.

PROFESSIONAL POSING TECHNIQUES FOR WEDDING AND PORTRAIT PHOTOGRAPHERS

Norman Phillips

Master the techniques you need to pose subjects successfully—whether you are working with men, women, children, or groups. $34.95 list, 8.5x11, 128p, 260 color photos, index, order no. 1810.

HOW TO START AND OPERATE A DIGITAL PORTRAIT PHOTOGRAPHY STUDIO

Lou Jacobs Jr.

Learn how to build a successful digital portrait photography business—or breathe new life into an existing studio. $39.95 list, 6x9, 224p, 150 color images, index, order no. 1811.

THE BEST OF FAMILY PORTRAIT PHOTOGRAPHY

Bill Hurter

Acclaimed photographers reveal the secrets behind their most successful family portraits. Packed with award-winning images and helpful techniques. $34.95 list, 8.5x11, 128p, 150 color photos, index, order no. 1812.

BLACK & WHITE PHOTOGRAPHY
TECHNIQUES WITH ADOBE® PHOTOSHOP®

Maurice Hamilton

Become a master of the black & white digital darkroom! Covers all the skills required to perfect your black & white images and produce dazzling fine-art prints. $34.95 list, 8.5x11, 128p, 150 color/b&w images, index, order no. 1813.

PROFESSIONAL MARKETING & SELLING TECHNIQUES FOR DIGITAL WEDDING PHOTOGRAPHERS 2nd Ed.

Jeff Hawkins and Kathleen Hawkins

Taking great photos isn't enough to ensure success! Become a master marketer and salesperson with these easy techniques. $34.95 list, 8.5x11, 128p, 150 color photos, index, order no. 1815.

MASTER COMPOSITION GUIDE FOR DIGITAL PHOTOGRAPHERS

Ernst Wildi

Composition can truly make or break an image. Master photographer Ernst Wildi shows you how to analyze your scene or subject and produce the best-possible image. $34.95 list, 8.5x11, 128p, 150 color photos, index, order no. 1817.

THE BEST OF ADOBE® PHOTOSHOP®

Bill Hurter

Rangefinder editor Bill Hurter calls upon the industry's top photographers to share their strategies for using Photoshop to intensify and sculpt their images. $34.95 list, 8.5x11, 128p, 170 color photos, 10 screen shots, index, order no. 1818.

MASTER LIGHTING TECHNIQUES
FOR OUTDOOR AND LOCATION DIGITAL PORTRAIT PHOTOGRAPHY

Stephen A. Dantzig

Use natural light alone or with flash fill, barebulb, and strobes to shoot perfect portraits all day long. $34.95 list, 8.5x11, 128p, 175 color photos, diagrams, index, order no. 1821.

BEGINNER'S GUIDE TO ADOBE® PHOTOSHOP®, 3rd Ed.

Michelle Perkins

Enhance your photos or add unique effects to any image. Short, easy-to-digest lessons will boost your confidence and ensure outstanding images. $34.95 list, 8.5x11, 128p, 80 color images, 120 screen shots, order no. 1823.

THE BEST OF PROFESSIONAL DIGITAL PHOTOGRAPHY

Bill Hurter

Digital imaging has a stronghold on photography. This book spotlights the methods that today's photographers use to create their best images. $34.95 list, 8.5x11, 128p, 180 color photos, 20 screen shots, index, order no. 1824.

ADOBE® PHOTOSHOP®
FOR UNDERWATER PHOTOGRAPHERS

Jack and Sue Drafahl

In this sequel to *Digital Imaging for the Underwater Photographer*, Jack and Sue Drafahl show you advanced techniques for solving a wide range of image problems that are unique to underwater photography. $39.95 list, 6x9, 224p, 100 color photos, 120 screen shots, index, order no. 1825.

PROFESSIONAL PORTRAIT LIGHTING
TECHNIQUES AND IMAGES FROM MASTER PHOTOGRAPHERS

Michelle Perkins

Get a behind-the-scenes look at the lighting techniques employed by the world's top portrait photographers. $34.95 list, 8.5x11, 128p, 200 color photos, index, order no. 2000.

MASTER POSING GUIDE
FOR CHILDREN'S PORTRAIT PHOTOGRAPHY

Norman Phillips

Create perfect portraits of infants, tots, kids, and teens. Includes techniques for standing, sitting, and floor poses for boys and girls, individuals, and groups. $34.95 list, 8.5x11, 128p, 305 color images, order no. 1826.

WEDDING PHOTOGRAPHER'S HANDBOOK

Bill Hurter

Learn to produce images with technical proficiency and superb, unbridled artistry. Includes images and insights from top industry pros. $34.95 list, 8.5x11, 128p, 180 color photos, 10 screen shots, index, order no. 1827.

RANGEFINDER'S PROFESSIONAL PHOTOGRAPHY

edited by Bill Hurter

Editor Bill Hurter shares over one hundred "recipes" from *Rangefinder's* popular cookbook series, showing you how to shoot, pose, light, and edit fabulous images. $34.95 list, 8.5x11, 128p, 150 color photos, index, order no. 1828.

LEGAL HANDBOOK FOR PHOTOGRAPHERS, 2nd Ed.

Bert P. Krages, Esq.

Learn what you can and cannot photograph, how to handle conflicts should they arise, how to protect your rights to your images in the digital age, and more. $34.95 list, 8.5x11, 128p, 80 b&w photos, index, order no. 1829.

MASTER GUIDE
FOR PROFESSIONAL PHOTOGRAPHERS

Patrick Rice

Turn your hobby into a thriving profession. This book covers equipment essentials, capture strategies, lighting, posing, digital effects, and more, providing a solid footing for a successful career. $34.95 list, 8.5x11, 128p, 200 color images, order no. 1830.

PROFESSIONAL FILTER TECHNIQUES
FOR DIGITAL PHOTOGRAPHERS

Stan Sholik

Select the best filter options for your photographic style and discover how their use will affect your images. $34.95 list, 8.5x11, 128p, 150 color images, index, order no. 1831.

MASTER'S GUIDE TO WEDDING PHOTOGRAPHY
CAPTURING UNFORGETTABLE MOMENTS AND LASTING IMPRESSIONS

Marcus Bell

Learn to capture the unique energy and mood of each wedding and build a lifelong client relationship. $34.95 list, 8.5x11, 128p, 200 color photos, index, order no. 1832.

MASTER LIGHTING GUIDE
FOR COMMERCIAL PHOTOGRAPHERS

Robert Morrissey

Use the tools and techniques pros rely on to land corporate clients. Includes diagrams, images, and techniques for a failsafe approach for shots that sell. $34.95 list, 8.5x11, 128p, 110 color photos, 125 diagrams, index, order no. 1833.

DIGITAL CAPTURE AND WORKFLOW
FOR PROFESSIONAL PHOTOGRAPHERS

Tom Lee

Cut your image-processing time by fine-tuning your workflow. Includes tips for working with Photoshop and Adobe Bridge, plus framing, matting, and more. $34.95 list, 8.5x11, 128p, 150 color images, index, order no. 1835.

THE PHOTOGRAPHER'S GUIDE TO COLOR MANAGEMENT
PROFESSIONAL TECHNIQUES FOR CONSISTENT RESULTS

Phil Nelson

Learn how to keep color consistent from device to device, ensuring greater efficiency and more accurate results. $34.95 list, 8.5x11, 128p, 175 color photos, index, order no. 1838.

SOFTBOX LIGHTING TECHNIQUES
FOR PROFESSIONAL PHOTOGRAPHERS

Stephen A. Dantzig

Learn to use one of photography's most popular lighting devices to produce soft and flawless effects for portraits, product shots, and more. $34.95 list, 8.5x11, 128p, 260 color images, index, order no. 1839.

CHILDREN'S PORTRAIT PHOTOGRAPHY HANDBOOK

Bill Hurter

Packed with inside tips from industry leaders, this book shows you the ins and outs of working with some of photography's most challenging subjects. $34.95 list, 8.5x11, 128p, 175 color images, index, order no. 1840.

JEFF SMITH'S LIGHTING FOR OUTDOOR AND LOCATION PORTRAIT PHOTOGRAPHY

Learn how to use light throughout the day—indoors and out—and make location portraits a highly profitable venture for your studio. $34.95 list, 8.5x11, 128p, 170 color images, index, order no. 1841.

PROFESSIONAL CHILDREN'S PORTRAIT PHOTOGRAPHY

Lou Jacobs Jr.

Fifteen top photographers reveal their most successful techniques—from working with un-ccoperative kids, to lighting, to marketing your studio. $34.95 list, 8.5x11, 128p, 200 color images, index, order no. 2001.

CHILDREN'S PORTRAIT PHOTOGRAPHY
A PHOTOJOURNALISTIC APPROACH

Kevin Newsome

Learn how to capture spirited images that reflect your young subject's unique personality and developmental stage. $34.95 list, 8.5x11, 128p, 150 color images, index, order no. 1843.

PROFESSIONAL PORTRAIT POSING
TECHNIQUES AND IMAGES FROM MASTER PHOTOGRAPHERS

Michelle Perkins

Learn how master photographers pose subjects to create unforgettable images. $34.95 list, 8.5x11, 128p, 175 color images, index, order no. 2002.